Rococo

PATTERNS • MUSTER • MOTIVOS • PADRÕES • MOTIVI • MOTIFS

THE PEPIN PRESS / AGILE RABBIT EDITIONS

Graphic Themes & Pictures

ISBN	Title
90 5768 001 7	1000 Decorated Initials
90 5768 003 3	Graphic Frames
90 5768 007 6	Images of the Human Body
90 5768 012 2	Geometric Patterns
90 5768 014 9	Menu Designs
90 5768 017 3	Classical Border Designs
90 5768 055 6	Signs & Symbols
90 5768 024 6	Bacteria And Other Micro Organisms
90 5768 023 8	Occult Images
90 5768 046 7	Erotic Images & Alphabets
90 5768 062 9	Fancy Alphabets
90 5768 056 4	Mini Icons
90 5768 016 5	Graphic Ornaments
90 5768 025 4	Compendium of Illustrations
90 5768 021 1	5000 Animals (4 CDs)
90 5768 065 3	Teknological

Styles (Historical)

ISBN	Title
90 5768 089 0	Early Christian Patterns
90 5768 090 4	Byzanthine
90 5768 091 2	Romanesque
90 5768 092 0	Gothic
90 5768 027 0	Mediæval Patterns
90 5768 034 3	Renaissance
90 5768 033 5	Baroque
90 5768 043 2	Rococo
90 5768 032 7	Patterns of the 19th Century
90 5768 013 0	Art Nouveau Designs
90 5768 060 2	Fancy Designs 1920
90 5768 059 9	Patterns of the 1930s
90 5768 072 6	Art Deco Designs

Styles (Cultural)

ISBN	Title
90 5768 006 8	Chinese Patterns
90 5768 009 2	Indian Textile Prints
90 5768 011 4	Ancient Mexican Designs
90 5768 020 3	Japanese Patterns
90 5768 022 x	Traditional Dutch Tile Designs
90 5768 028 9	Islamic Designs
90 5768 029 7	Persian Designs
90 5768 036 X	Turkish Designs
90 5768 042 4	Elements of Chinese & Japanese Design
90 5768 071 8	Arabian Geometric Patterns

Textile Patterns

ISBN	Title
90 5768 004 1	Batik Patterns
90 5768 030 0	Weaving Patterns
90 5768 037 8	Lace
90 5768 038 6	Embroidery
90 5768 058 0	Ikat Patterns
90 5768 075 0	Indian Textiles

Folding & Packaging

ISBN	Title
90 5768 039 4	How To Fold
90 5768 040 8	Folding Patterns for Display & Publicity
90 5768 044 0	Structural Package Designs
90 5768 053 x	Mail It!
90 5768 054 8	Special Packaging

Web Design

ISBN	Title
90 5768 018 1	Web Design Index 1
90 5768 026 2	Web Design Index 2
90 5768 045 9	Web Design Index 3
90 5768 063 7	Web Design Index 4
90 5768 068 8	Web Design Index 5
90 5768 093 9	Web Design Index 6
90 5768 069 6	Web Design by Content

Photographs

ISBN	Title
90 5768 047 5	Fruit
90 5768 048 3	Vegetables
90 5768 057 2	Body Parts
90 5768 064 5	Body Parts (USA/Asia Ed)
90 5768 079 3	Male Body Parts
90 5768 080 7	Body Parts in Black & White
90 5768 067 x	Images of the Universe
90 5768 074 2	Rejected Photographs
90 5768 070 x	Flowers

Miscellaneous

ISBN	Title
90 5768 005 x	Floral Patterns
90 5768 052 1	Astrology
90 5768 051 3	Historical & Curious Maps
90 5768 066 1	Picture Atlas of World Mythology
90 5768 061 0	Wallpaper Designs
90 5768 076 9	Watercolour Patterns

More titles in preparation. In addition to the Agile Rabbit series of book +CD-ROM sets, The Pepin Press publishes a wide range of books on art, design, architecture, applied art, and popular culture.

Please visit www.pepinpress.com for more information.

COLOPHON

Copyright © 2005 Pepin van Roojen
All rights reserved.

The Pepin Press | Agile Rabbit Editions
P.O. Box 10349
1001 EH Amsterdam, The Netherlands

Tel +31 20 420 20 21
Fax +31 20 420 11 52
mail@pepinpress.com
www.pepinpress.com

Design & text by Pepin van Roojen

Picture scanning by Jakob Hronek (colour),
Joost Baardman (linework) and
Pepin van Roojen

Translations: LocTeam, Barcelona (Spanish,
Italian, French, and German) and TheBigWord,
Leeds (Japanese and Chinese)

ISBN 90 5768 043 2

10 9 8 7 6 5 4 3 2 1
2010 09 08 07 06 05

Manufactured in Singapore

CONTENTS

Introduction in English	4
Einführung auf deutsch	6
Introduction en français	8
Introducción en Español	10
Introduzione in Italiano	12
概説（日本語）	14
中文簡介	14
Designs	15–112

Free CD-Rom in the inside back cover

THE PEPIN PRESS / AGILE RABBIT EDITIONS

The Pepin Press / Agile Rabbit Editions book and CD-ROM sets offer a wealth of visual information and ready-to-use material for creative people. We publish various series as part of this line: graphic themes and pictures, photographs, packaging, web design, textile patterns, styles as defined by culture and the historical epochs that have generated a distinctive ornamental style. A list of available and forthcoming titles can be found at the beginning of this book. Many more volumes are being readied for publication, so we suggest you check our website from time to time for new additions.

EUROPEAN DESIGN 200 - 1900 AD

The present volume is part of a series that covers the decorative styles prevalent in Europe since the beginning of the Western calendar. Because of the practical nature of this series, we tend to focus on two-dimensional design, often culled from fabrics, wall coverings and printed paper, but also from patterns used to decorate flat surfaces in other forms of applied arts, such as furniture and metalwork. The original drawings are meticulously restored and often vectorised.

This series begins with the archaic styles of the Early Christian period (2nd to 7th centuries AD), the Byzantine (5th to 15th centuries) and the subsequent Mediæval epochs, including the Romanesque (10th to mid-12th centuries) and Late Gothic (13th and 14th centuries). Although sometimes looked down upon because they were believed not to match the sophistication of the arts from ancient Rome, Mediæval pattern design and ornamentation, with their austere use of colour and rudimentary forms, can be of stunning harmony and beauty.

A revival of interest in the classical arts of Ancient Greece and Rome came with the Renaissance in the 15th and 16th centuries. Although the sculpture and architectural ornamentation during the Renaissance tended to be complex, two-dimensional patterns were often more subdued. The repetitive designs of the Renaissance can sometimes be confused with those of the Gothic period.

The predominant style of the 17th and first half of the 18th centuries was the Baroque. The applied arts from this period are characterised by the use of bold, sometimes overstated forms, including exaggerated curves and curlicues. While the floral compositions from the Baroque were often overpowering, the Rococo - the predominantly French style from the mid-18th century - displayed flowers in a more elegant fashion. During this period, the use of exquisite bouquets as a decorative detail became very popular.
The latter part of the 18th century showed the rise of two apparently opposing styles: the rather strict Neoclassicism and the joyful Romanticism. Both styles thrived until the mid-19th century.

In general, 19th century design was not particularly innovative, though it was highly eclectic. The great styles from the past were revived and often combined with stylistic discoveries from Europe's numerous colonies. However, the end of the 19th century witnessed the emergence of a truly new style, Art Nouveau, which, though eclectic in nature, made a radical break with classical ornamentation.

BOOK AND CD-ROM

The images in this book can be used as a graphic resource and for inspiration. All the illustrations are stored in high-resolution format on the enclosed free CD-ROM and are ready to use for professional quality printed media and web page design.
The pictures can also be used to produce postcards, either on paper or digitally, or to decorate your letters, flyers, etc. They can be imported directly from the CD into most design, image-manipulation, illustration, word-processing and e-mail programs. Some programs will allow you to access the images directly; in others, you will first have to create a document, and then import the images. Please consult your software manual for instructions.
The names of the files on the CD-ROM correspond with the page numbers in this book. The CD-ROM comes free with this book, but is not for sale separately. The publishers do not accept any responsibility should the CD not be compatible with your system.
For non-professional applications, single images can be used free of charge. The images cannot be used for any type of commercial or otherwise professional application – including all types of printed or digital publications – without prior permission from The Pepin Press / Agile Rabbit Editions.

The files on the CD-ROM are high quality and sufficiently large for most applications. However, larger or vectorised files are available for most images and can be ordered from The Pepin Press / Agile Rabbit Editions.

For inquiries about permissions and fees, please contact:
mail@pepinpress.com
Fax +31 20 4201152

THE PEPIN PRESS / AGILE RABBIT EDITIONS

Die aus Buch und CD-ROM bestehenden Sets von The Pepin Press / Agile Rabbit Editions bieten eine Fülle an visuellen Informationen und sofort verwendbarem Material für kreative Menschen. Im Rahmen dieser Reihe veröffentlichen wir verschiedene Serien: grafische Themen und Bilder, Fotos, Aufmachungen, Webdesigns, Stoffmuster sowie von Kulturströmungen und geschichtlichen Epochen geprägte Stilrichtungen, die eine eigene dekorative Stilrichtung hervorgebracht haben. Eine Liste der verfügbaren und kommenden Titel finden Sie am Anfang dieses Buchs. Viele weitere Bände befinden sich gerade in Vorbereitung – besuchen Sie daher regelmäßig unsere Website, um sich über Neuerscheinungen zu informieren.

EUROPÄISCHES DESIGN 200 – 1900 n. Chr.

Der vorliegende Band ist Teil einer Serie, die die in Europa seit Beginn des westlichen Kalenders vorherrschenden dekorative Stilrichtungen umfasst. Aufgrund der praktischen Ausrichtung der Serie konzentrieren wir uns vorrangig auf zweidimensionale Designs, die oft auf Stoffmuster, Wandtapeten und bedrucktes Papier zurückgehen, aber ebenso auf Mustern basieren, die zur Dekoration von glatten Oberflächen in anderen Bereichen der angewandten Kunst, wie beispielsweise Möbel und Metallarbeit, verwendet wurden. Die ursprünglichen Zeichnungen wurden minuziös rekonstruiert und in vielen Fällen vektorisiert.

Die vorliegende Serie beginnt mit den altertümlichen Stilrichtungen der frühchristlichen Periode (2. bis 7. Jahrhundert n. Chr.), der byzantinischen Epoche (5. bis 15. Jahrhundert) und den darauffolgenden Epochen des Mittelalters, einschließlich der Romanik (10. bis Mitte des 12. Jahrhundert) und der Spätgotik (13. und 14. Jahrhundert).
Obwohl mittelalterliche Muster manchmal geringgeschätzt wurden, da man meinte, dass diesen die Raffinesse der Künste des antiken Roms fehlten, überzeugen mittelalterliche Designs und Ornamente mit ihrer strengen Farbgebung und ihren rudimentären Formen durch eine erstaunliche Harmonie und Schönheit.

Mit der Renaissance des 15. und 16. Jahrhunderts kam es zu einem erneuten Aufleben des Interesses für die klassische Kunst des antiken Griechenlands und Roms. Während die Skulpturen und architektonischen Ornamente in der Renaissance eher komplexe Designs aufwiesen, waren die zweidimensionalen Muster oft eher dezent. Die sich wiederholenden Muster der Renaissance können leicht mit jenen der Gotik verwechselt werden.

Das 17. Jahrhundert stand ebenso wie die erste Hälfte des 18. Jahrhunderts ganz im Zeichen des Barock. Die angewandten Künste dieser Periode sind von kühnen, manchmal übertriebenen Formen, sowie ausschweifenden Kurven und Schnörkeln geprägt. Während die floralen Kompositionen des Barock oft überladen wirkten, wurden im Rokoko – dem vorwiegend französischen Stil aus der Mitte des 18. Jahrhunderts – Blumen in einer eleganteren Art und Weise zum Ausdruck gebracht. In dieser Periode erfreute sich die Verwendung exquisiter Blumensträuße als dekoratives Detail immer größerer Beliebtheit.

Gegen Ende des 18. Jahrhunderts entwickelten sich zwei scheinbar entgegengesetzte Stilrichtungen: der eher strenge Neoklassizismus und die liebliche Romantik. Beide Stile waren bis zur Mitte des 19. Jahrhunderts äußerst beliebt.

Generell muss man sagen, dass das Design im 19. Jahrhundert zwar sehr vielseitig war, aber dennoch keine besonderen Innovationen hervorbrachte. Die großen Stilrichtungen der Vergangenheit wurden zu neuem Leben erweckt und oft mit stilistischen Entdeckungen aus den zahlreichen europäischen Kolonien verbunden. Doch am Ende des 19. Jahrhunderts entstand mit dem Art Nouveau eine wahrlich neue Stilrichtung, die trotz ihrer Vielseitigkeit einen radikalen Bruch mit der klassischen Ornamentierung darstellte.

BUCH UND CR-ROM

Dieses Buch enthält Bilder, die als Ausgangsmaterial für graphische Zwecke oder als Anregung genutzt werden können. Alle Abbildungen sind in hoher Auflösung auf der beiliegenden Gratis-CD-ROM gespeichert und lassen sich direkt zum Drucken in professioneller Qualität oder zur Gestaltung von Websites einsetzen.
Sie können sie auch als Motive für Postkarten auf Karton oder in digitaler Form, oder als Ausschmückung für Ihre Briefe, Flyer etc. verwenden. Die Bilder lassen sich direkt in die meisten Zeichen-, Bildbearbeitungs-, Illustrations-, Textverarbeitungs- und E-Mail-Programme laden, ohne dass zusätzliche Programme installiert werden müssen. In einigen Programmen können die Dokumente direkt geladen werden, in anderen müssen Sie zuerst ein Dokument anlegen und können dann die Datei importieren. Genauere Hinweise dazu finden Sie im Handbuch zu Ihrer Software.
Die Namen der Bilddateien auf der CD-ROM entsprechen den Seitenzahlen dieses Buchs. Die CD-ROM wird kostenlos mit dem Buch geliefert und ist nicht separat verkäuflich. Der Verlag haftet nicht für Inkompatibilität der CD-ROM mit Ihrem System.
Für nicht professionelle Anwendungen können einzelne Bilder kostenfrei genutzt werden. Die Bilder dürfen ohne vorherige Genehmigung von The Pepin Press / Agile Rabbit Editions nicht für kommerzielle oder sonstige professionelle Anwendungen einschließlich aller Arten von gedruckten oder digitalen Medien eingesetzt werden.

Die Dateien auf der CD-ROM sind in Bezug auf Qualität und Größe für die meisten Verwendungszwecke geeignet. Zusätzlich können jedoch größere Dateien oder Vektorgrafiken der meisten Bilder bei The Pepin Press / Agile Rabbit Editions bestellt werden.

Für Fragen zu Genehmigungen und Preisen wenden Sie sich bitte an:
mail@pepinpress.com
Fax +31 20 4201152

THE PEPIN PRESS / AGILE RABBIT EDITIONS

Les coffrets Livre + CD-ROM des éditions Pepin Press / Agile Rabbit proposent aux esprits créatifs une mine d'informations visuelles et de documents prêts à l'emploi. Dans le cadre de cette collection, nous publions plusieurs séries : thèmes et images graphiques, photographies, packaging, création de sites web, motifs textiles, styles tels qu'ils sont définis par chaque cultureet époques de l'histoire ayant engendré un style ornemental caractéristique. Vous trouverez une liste des titres disponibles et à venir au début de cet ouvrage. De nombreux autres volumes étant en cours de préparation, nous vous suggérons de consulter notre site web de temps à autre pour prendre connaissance des nouveautés.

ORNEMENTATION EUROPÉENNE DU 3ÈME AU 20ÈME SIÈCLE APRÉS J-C

Le présent volume fait partie d'une série traitant des styles décoratifs répandus en Europe depuis le début du calendrier occidental. Étant donné le caractère pratique de cette série, nous avons essayé de nous concentrer sur une ornementation bidimensionnelle, souvent sélectionnée parmi des tissus, des revêtements muraux et des papiers imprimés mais également parmi des motifs utilisés pour décorer des surfaces planes dans d'autres formes d'arts appliqués, comme celles du mobilier et de la ferronnerie. Les dessins originaux sont reproduits méticuleusement et souvent vectorisés.

Cette série commence par les styles archaïques du début de la période chrétienne (du 2ème au 7ème siècles après J-C), le byzantin (5ème au 15ème siècles) et les époques médiévales postérieures, y compris la période romane (du 10ème siècle jusqu'à la moitié du 12ème siècle) et la fin du gothique (13ème et 14ème siècles).
Bien que parfois méprisés car loin d'égaler la sophistication des arts de la Rome antique selon certains, le dessin et l'ornementation du style médiéval peuvent être d'une beauté et d'une harmonie remarquables, avec leur utilisation austère de la couleur et leurs formes rudimentaires.

Un regain d'intérêt pour les arts classiques de la Grèce et la Rome antiques est apparu avec la Renaissance aux 15ème et 16ème siècles. Si pendant la Renaissance la sculpture et l'ornementation architecturale avaient tendance à être complexes, les motifs bidimensionnels étaient souvent plus atténués. On peut parfois confondre les motifs répétitifs de la Renaissance avec ceux de la période gothique.

Le style prédominant du 17ème siècle et de la première moitié du 18ème siècle était le baroque. Les arts appliqués de cette période sont caractérisés par l'usage de formes hardies, parfois exagérées, et même de courbes et fioritures excessives. Tandis que les compositions florales du baroque étaient souvent oppressantes, le rococo - style principalement français du milieu du 18ème siècle - disposait les fleurs de manière plus élégante. Pendant cette période, l'usage de bouquets raffinés comme détail décoratif était très en vogue.

La dernière partie du 18ème siècle a révélé l'essor de deux styles apparemment opposés : le néoclassicisme plutôt sévère et le joyeux romantisme. Tout deux ont prospéré jusqu'au milieu du 19ème siècle.

Bien que très éclectique, le dessin du 19ème siècle ne fut généralement pas particulièrement innovant. Les grands styles du passé furent repris et souvent combinés avec des découvertes stylistiques faites dans les nombreuses colonies européennes. Cependant, la fin du 19ème siècle a été témoin de la naissance d'un style véritablement nouveau, l'Art nouveau, qui, malgré son caractère éclectique, a constitué une rupture radicale avec la décoration classique.

LIVRE ET CD-ROM

Cet ouvrage renferme des illustrations destinées à servir d'inspiration ou de ressources graphiques. Toutes les images sont stockées en format haute définition sur le CD-ROM et permettent la réalisation d'impressions de qualité professionnelle et la création de pages web. Elles permettent également de créer des cartes postales, aussi bien sur papier que virtuelles, ou d'agrémenter vos courriers, prospectus et autres.
Vous pouvez les importer directement à partir du CD dans la plupart des applications de création, manipulation graphique, illustration, traitement de texte et messagerie. Certaines applications permettent d'accéder directement aux images, tandis qu'avec d'autres, vous devrez d'abord créer un document, puis y importer les images. Veuillez consulter les instructions dans le manuel du logiciel concerné.

Sur le CD, les noms des fichiers correspondent aux numéros de pages du livre.
Le CD-ROM est fourni gratuitement avec le livre et ne peut être vendu séparément. L'éditeur décline toute responsabilité si ce CD n'est pas compatible avec votre ordinateur. Vous pouvez utiliser les images individuelles gratuitement avec des applications non-professionnelles. Il est interdit d'utiliser les images avec des applications de type professionnel ou commercial (y compris avec tout type de publication numérique ou imprimée) sans l'autorisation préalable des éditions Pepin Press / Agile Rabbit.

Les fichiers figurant sur le CD-ROM sont de qualité supérieure et de taille acceptable pour la plupart des applications. Les fichiers plus volumineux ou vectorisés sont disponibles pour la plupart des images et peuvent être commandés auprès des éditions Pepin Press / Agile Rabbit.

Adresse électronique et numéro de télécopie à utiliser pour tout renseignement relatif aux autorisations et aux frais d'utilisation :
mail@pepinpress.com
Télécopie : +31 20 4201152

THE PEPIN PRESS / AGILE RABBIT EDITIONS

Los libros con CD-ROM incluido que nos propone The Pepin Press / Agile Rabbit Editions ponen a disposición de los creativos una amplísima información visual y material listo para ser utilizado. Dentro de la colección Agile Rabbit se publican diferentes series: motivos gráficos e ilustraciones, fotografías, embalaje, diseño de páginas web, motivos textiles, y estilos definidos por una determinada cultura y por las épocas históricas que han generado un estilo ornamental distintivo. Al principio de este libro encontrará una lista de los títulos disponibles y en preparación. Estamos trabajando en muchos más volúmenes, por lo que le aconsejamos que visite periódicamente nuestra página web para estar informado de todas las novedades.

DISEÑO EUROPEO 200 - 1900 AD

Este libro forma parte de una colección dedicada a los estilos decorativos que prevalecieron en Europa desde la instauración del calendario occidental. A causa del carácter práctico de la misma, nos hemos centrado en el diseño bidimensional, que en muchas ocasiones hemos extraído de tejidos, decoraciones de paredes y papel impreso, sin por ello desdeñar los patrones utilizados para decorar superficies planas en otras manifestaciones de las artes aplicadas, como los muebles o el trabajo en metal. Los dibujos originales han sido restaurados meticulosamente y, a menudo, vectorizados.

Esta colección se inicia con los estilos arcaicos de principios de la era cristiana (siglos II a VII a.C.), el periodo bizantino (siglos V a XV) y los distintos periodos medievales, incluyendo el románico (siglo x a mediados del XII) y el gótico tardío (siglos XIII y XIV).
A pesar de que en ocasiones han sido menospreciados por no estar a la altura de la sofisticación del arte de la antigua Roma, el diseño y la ornamentación medievales, con su austero uso del color y sus formas rudimentarias, pueden alcanzar niveles sorprendentes de armonía y belleza.

Durante el Renacimiento, que se extiende entre los siglos XV y XVI, asistimos a un renovado interés por las artes clásicas de Grecia y Roma. A pesar de que la ornamentación renacentista aplicada a la escultura y la arquitectura tendían a la complejidad, a menudo los patrones bidimensionales eran más comedidos. En ocasiones, los diseños repetitivos de este periodo pueden confundirse con los de estilo gótico.

El siglo XVII y la primera mitad del XVIII fueron los años del barroco. Las artes aplicadas de esta era se caracterizan por el uso de formas enérgicas y a menudo exageradas, en las que no podían faltar las curvas y filigranas sin medida. Mientras que las composiciones florales del barroco resultaban a menudo demasiado pomposas, el rococó, un estilo que se desarrolló predominantemente en Francia a partir de mediados del siglo XVIII, recreó las flores de un modo más elegante. Durante esta etapa, gozó de gran popularidad la utilización de ramos exquisitos como detalle decorativo.

Durante la segunda mitad de este siglo asistimos al auge de dos estilos aparentemente opuestos: el estricto neoclasicismo y el alegre romanticismo, que pervivieron hasta mediados del XIX.

En general, el diseño del siglo XIX no destacó por su carácter innovador, si bien no podemos negar su eclecticismo. Se recuperaron los grandes estilos del pasado y, a menudo, se combinaron con las novedades estéticas procedentes de las numerosas colonias europeas. No obstante, a finales de dicho siglo emergió un estilo realmente nuevo, el art nouveau, que supuso una ruptura radical con la ornamentación clásica a pesar de su naturaleza ecléctica.

LIBRO Y CD-ROM

En este libro podrá encontrar imágenes que le servirán como fuente de material gráfico o como inspiración para realizar sus propios diseños. Se adjunta un CD-ROM gratuito donde hallará todas las ilustraciones en un formato de alta resolución, con las que podrá conseguir una impresión de calidad profesional y diseñar páginas web.
Las imágenes pueden también emplearse para realizar postales, de papel o digitales, o para decorar cartas, folletos, etc. Se pueden importar desde el CD a la mayoría de programas de diseño, manipulación de imágenes, dibujo, tratamiento de textos y correo electrónico, sin necesidad de utilizar un programa de instalación. Algunos programas le permitirán acceder a las imágenes directamente; otros, sin embargo, requieren la creación previa de un documento para importar las imágenes. Consulte su manual de software en caso de duda.
Los nombres de los archivos del CD-ROM se corresponden con los números de página de este libro. El CD-ROM se ofrece de manera gratuita con este libro, pero está prohibida su venta por separado. Los editores no asumen ninguna responsabilidad en el caso de que el CD no sea compatible con su sistema.
Se autoriza el uso de estas imágenes de manera gratuita para aplicaciones no profesionales. No se podrán emplear en aplicaciones de tipo profesional o comercial (incluido cualquier tipo de publicación impresa o digital) sin la autorización previa de The Pepin Press / Agile Rabbit Editions.

Los archivos incluidos en el CD-ROM son de gran calidad y su tamaño es adecuado para la mayor parte de las aplicaciones. No obstante, para la mayoría de las imágenes existen archivos de mayor tamaño o vectorizados, que pueden solicitarse a The Pepin Press / Agile Rabbit Editions.

Para más información acerca de autorizaciones y tarifas:

mail@pepinpress.com
Fax +31 20 4201152

THE PEPIN PRESS / AGILE RABBIT EDITIONS

Il libro della Pepin Press / Agile Rabbit Editions e l'accluso CD-ROM mettono a disposizione dei creativi un ricco supporto visivo e materiale pronto per l'uso. La collana comprende diverse serie: motivi grafici e illustrazioni, fotografie, packaging, web design, motivi per tessuti, stili secondo la definizione data dalla cultura e dalle epoche storiche che hanno prodotto uno stile ornamentale particolare. Nelle prime pagine del libro è riportato l'elenco delle opere già in catalogo e di quelle in via di pubblicazione. Sono molti gli altri testi in via di pubblicazione, quindi consigliamo di visitare periodicamente il nostro sito internet per essere informati sulle novità.

IL DESIGN EUROPEO DAL 200 AL 1900

Questo volume fa parte di una serie dedicata agli stili decorativi che hanno dominato in Europa dall'avvento del calendario occidentale. Data la natura pratica di questa serie, tendiamo a richiamare l'attenzione sul design bidimensionale, spesso imitazione di tessuti, carte da parati e carta stampata, ma ricavato anche da motivi usati per decorare superfici piane in altre forme di arti applicate, quali mobili e lavori su metallo. I disegni originali sono stati restaurati con molta cura e spesso vettorizzati.

La serie inizia dagli stili arcaici del primo periodo cristiano (II-VII secolo) e prosegue con il bizantino (V-XV secolo) e le successive epoche medievali, soffermandosi anche sul romanico (V-metà del XII secolo) e sul tardo gotico (XIII-XIV secolo).
Anche se a volte guardati dall'alto in basso perché non ritenuti in grado di reggere il confronto con la ricercatezza delle arti dell'antica Roma, il design e l'ornamento dei motivi medievali, con l'uso austero del colore e le forme rudimentali, possono raggiungere livelli stupefacenti di armonia e di bellezza.

Nel Rinascimento, nel XV-XVI secolo, si risvegliò l'interesse nei confronti delle arti classiche dell'antica Grecia e dell'antica Roma. Anche se la scultura e l'ornamento architettonico nel Rinascimento avevano la tendenza ad essere elaborati, i motivi bidimensionali furono spesso più smorzati. I motivi ripetitivi del Rinascimento si possono a volte confondere con quelli del periodo gotico.

Il barocco fu lo stile predominante del XVII secolo e della prima metà del XVIII. Le arti applicate di questo periodo sono caratterizzate dall'uso di forme ardite, a volte esagerate, con abbondanza di curve e volute. Se le composizioni floreali del barocco risultavano sovente troppo pompose, il rococò, lo stile francese che si affermò intorno alla metà del XVIII secolo, è caratterizzato da un uso più elegante dell'elemento floreale. In questo periodo, l'utilizzo di raffinati bouquet come dettaglio decorativo diventò molto popolare.
L'ultima parte del XVIII secolo vide emergere due stili apparentemente opposti: il rigoroso neoclassicismo e il vivace romanticismo. Entrambi prosperarono fino alla metà del XIX secolo.

In generale, il design del XIX secolo non fu particolarmente innovativo, nonostante la sua accentuata ecletticità. I grandi stili del passato assursero a nuova vita e spesso convissero con le scoperte stilistiche provenienti dalle numerose colonie europee. Tuttavia, alla fine del XIX emerse uno stile veramente nuovo, l'art nouveau, che, pur essendo eclettico di natura, ruppe radicalmente con l'ornamento classico.

LIBRO E CD-ROM

Questo libro contiene immagini che possono essere utilizzate come risorsa grafica o come fonte di ispirazione. La maggior parte delle illustrazioni sono contenute nel CD-ROM gratuito allegato, in formato ad alta risoluzione e pronte per essere utilizzate per pubblicazioni professionali e pagine web.
Possono essere inoltre usate per creare cartoline, su carta o digitali, o per abbellire lettere, opuscoli, ecc. Dal CD, le immagini possono essere importate direttamente nella maggior parte dei programmi di grafica, di ritocco, di illustrazione, di scrittura e di posta elettronica; non è richiesto alcun tipo di installazione. Alcuni programmi vi consentiranno di accedere alle immagini direttamente; in altri, invece, dovrete prima creare un documento e poi importare le immagini. Consultate il manuale del software per maggiori informazioni.
I nomi dei file del CD-ROM corrispondono ai numeri delle pagine del libro. Il CD-ROM è allegato gratuitamente al libro e non può essere venduto separatamente. L'editore non può essere ritenuto responsabile qualora il CD non fosse compatibile con il sistema posseduto.
Per le applicazioni non professionali, le singole immagini possono essere usate gratis. Per l'utilizzo delle immagini a scopo professionale o commerciale, comprese tutte le pubblicazioni digitali o stampate, è necessaria la relativa autorizzazione da parte della casa editrice The Pepin Press / Agile Rabbit Editions.

I file sul CD-ROM sono di alta qualità e sufficientemente grandi per poter essere usati nella maggior parte delle applicazioni. File di maggiori dimensioni possono essere richiesti e ordinati, se necessario, alla casa editrice The Pepin Press / Agile Rabbit Editions.

Per ulteriori informazioni rivolgetevi a:
mail@pepinpress.com
Fax +31 20 4201152

日本語

本書にはグラフィック リソースやインスピレーションとして使用できる美しいイメージ画像が含まれています。すべてのイラストレーションは、無料の付属 CD-ROM（Mac および Windows 用）に高解像度で保存されており、これらを利用してプロ品質の印刷物や WEB ページを簡単に作成することができます。また、紙ベースまたはデジタルの葉書の作成やレター、ちらしの装飾等に使用することもできます。

これらの画像は、CD から主なデザイン、画像処理、イラスト、ワープロ、E メールソフトウェアに直接取り込むことができます。インストレーションは必要ありません。プログラムによっては、画像に直接アクセスできる場合や、一旦ドキュメントを作成した後に画像を取り込む場合等があります。詳細は、ご使用のソフトウェアのマニュアルをご参照下さい。

CD-ROM 上のファイル名は、本書のページ数に対応しています。ページに複数の画像が含まれる場合は、左から右、上から下の順番で番号がつけられ、ページ番号に続く数字または下記のレターコードで識別されます。

T＝トップ（上部）、B＝ボトム（下部）、C＝センター（中央）、L＝レフト（左）、R＝ライト（右）

CD-ROM は本書の付属品であり、別売されておりません。CD がお客様のシステムと互換でなかった場合、発行者は責任を負わないことをご了承下さい。

プロ用以外のアプリケーションで、画像を一回のみ無料で使用することができます。The Pepin Press / Agile Rabbit Editions から事前許可を得ることなく、あらゆる形体の印刷物、デジタル出版物をはじめとする、あらゆる種類の商業用ならびにプロ用アプリケーションで画像を使用することを禁止します。

使用許可と料金については、下記までお問い合わせ下さい。
mail@pepinpress.com
ファックス： +31 20 4201152

中 文

本書包含精美圖片，可以作為圖片資源或激發靈感的資料使用。這些圖片存儲在所附的高清晰度免費 CD-ROM (可在 Mac 和 Windows 下使用) 中，可用於專業的高品質印刷媒體和網頁設計。圖片還可以用於製作紙質和數字明信片，或裝飾您的信封、傳單等。您無需安裝即可以把圖片直接從 CD 調入大多數的設計、圖像處理、圖片、文字處理和電子郵件程序。有些程序允許您直接使用圖片；另外一些，您則需要先創建一個文件，然後引入圖片。用法說明請參閱軟體說明書。

在 CD 中的文件名稱是與書中的頁碼相對應的。如果書頁中的圖片超過一幅，其順序為從左到右，從上到下。這會在書頁號後加一個數字來表示，或者是加一個字母：T = 上，B = 下，C = 中，L = 左，R = 右。

本書附帶的 CD-ROM 是免費的，但 CD-ROM 不單獨出售。如果 CD 與您的系統不相容，出版商不承擔任何責任。

就非專業的用途而言，可以免費使用單個圖片。若未事先得到 The Pepin Press/Agile Rabbit Editions 的許可，不得將圖片用於任何其他類型的商業或專業用途 - 包括所有類型的印刷或數字出版物。

有關許可及收費的詢問，請查詢：
Mail@pepinpress.com
傳真： +31 20 4201152

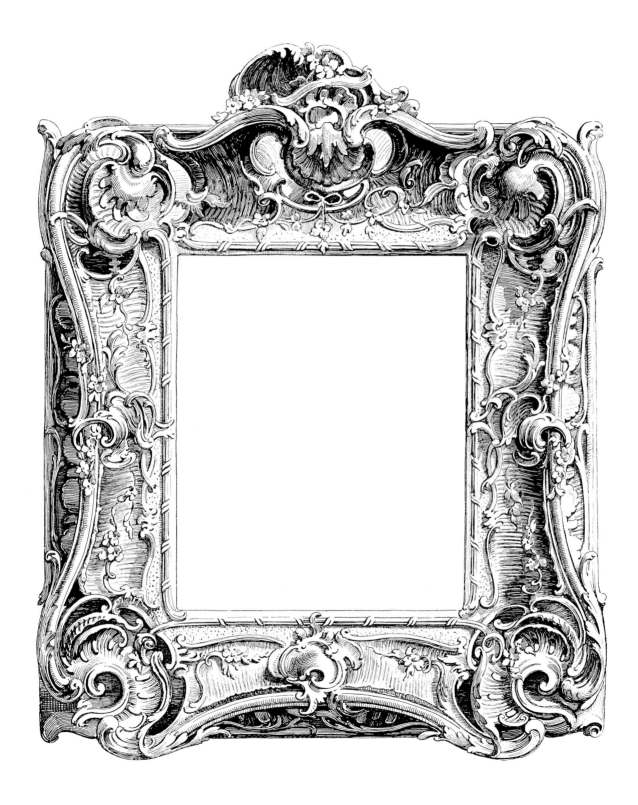

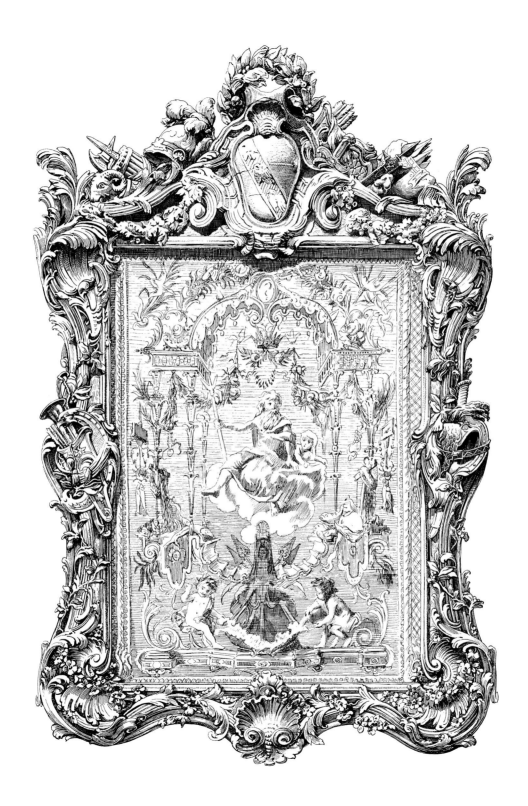

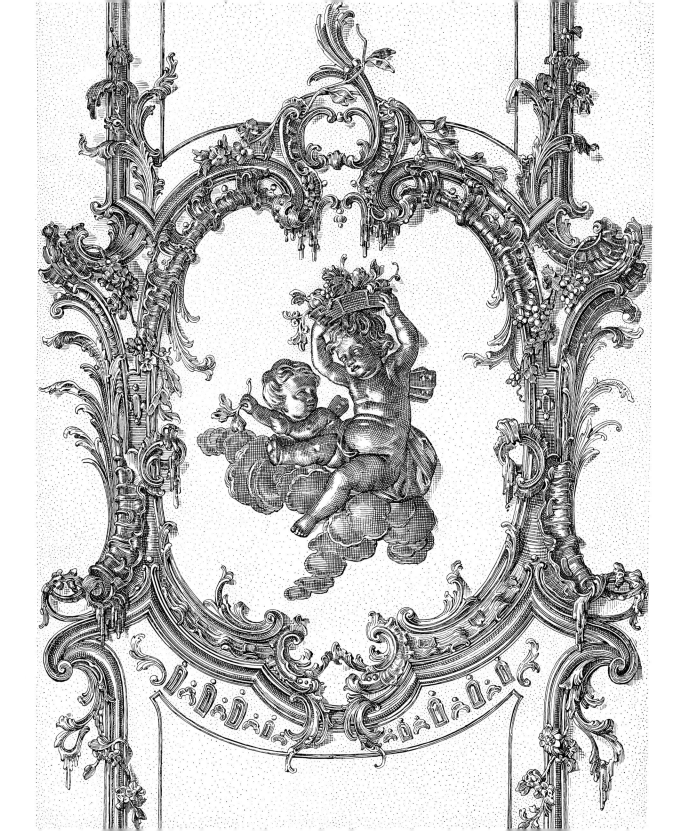

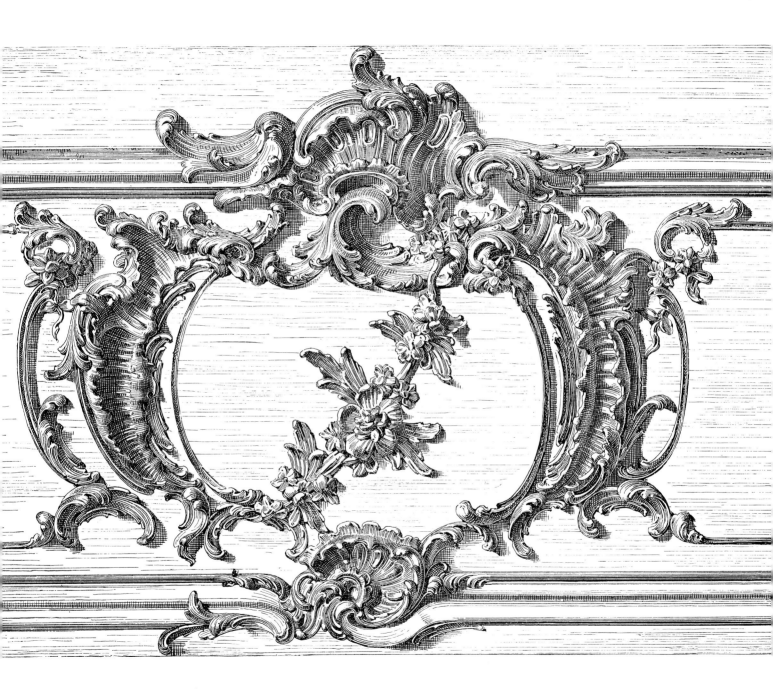

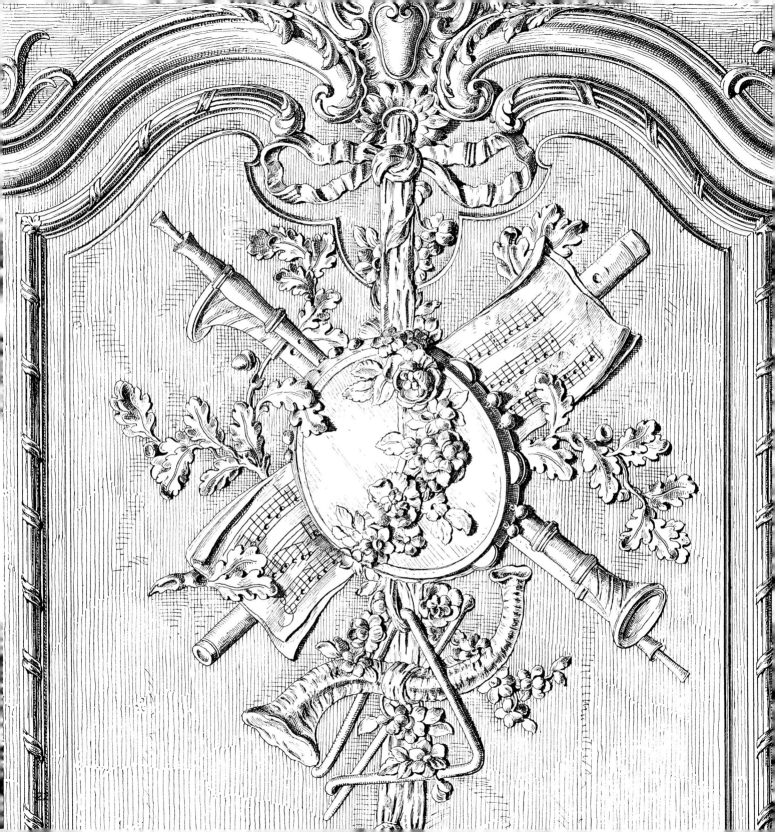

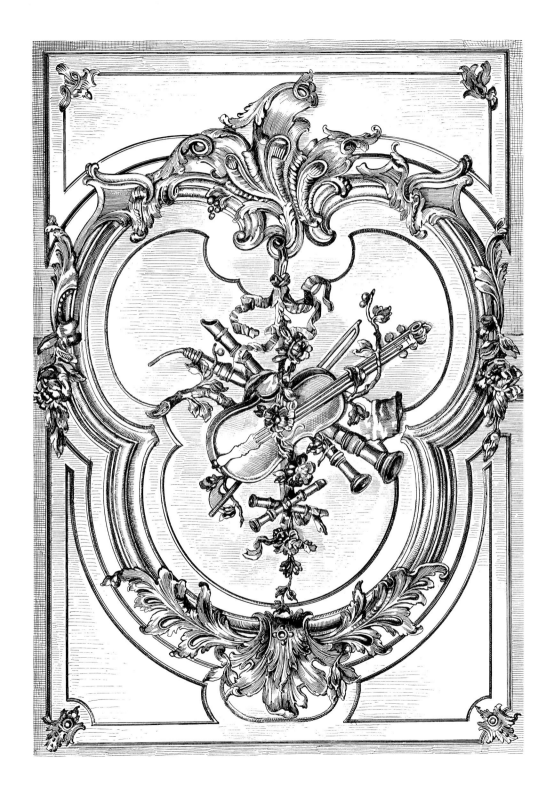

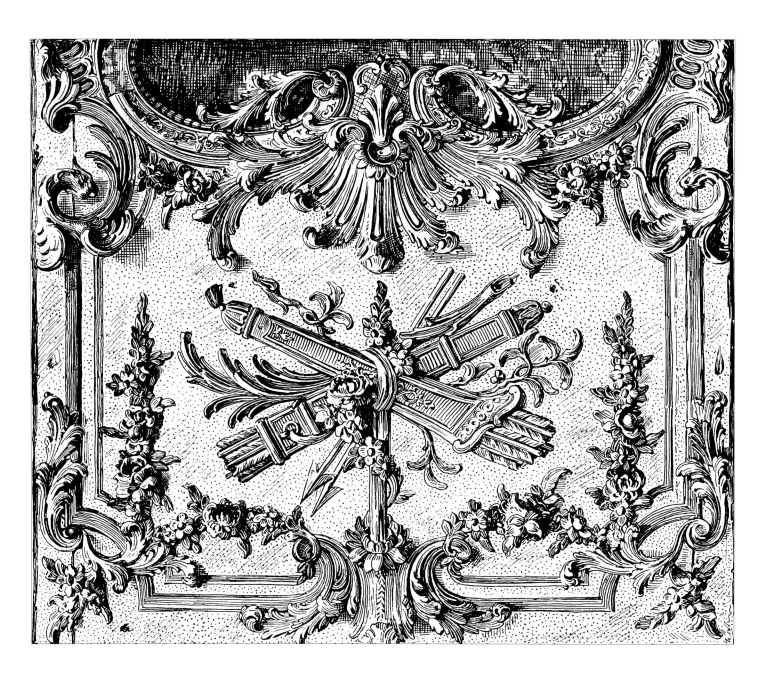

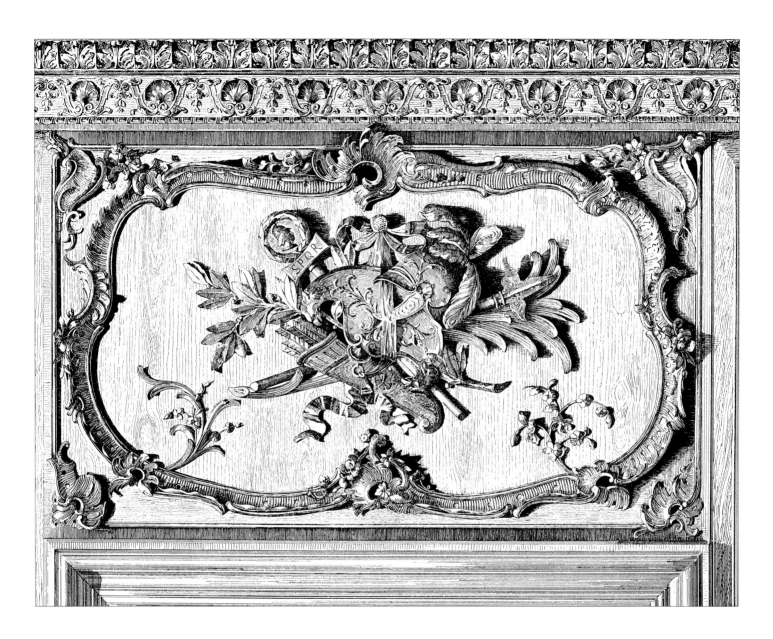

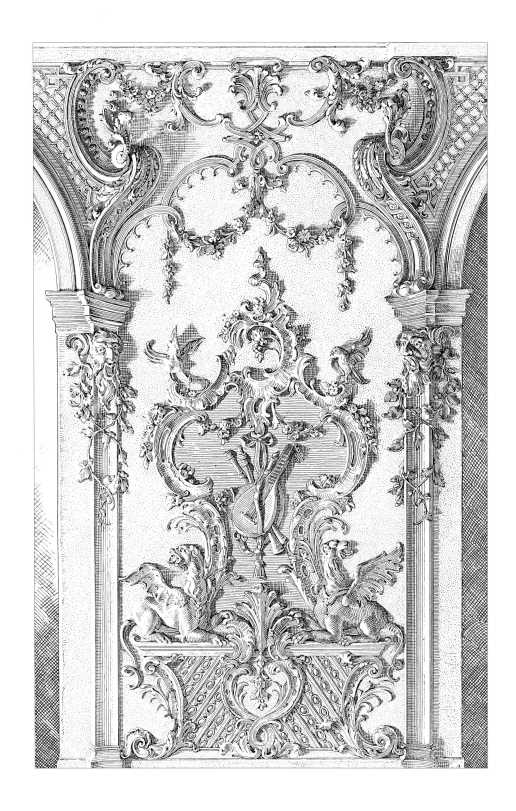

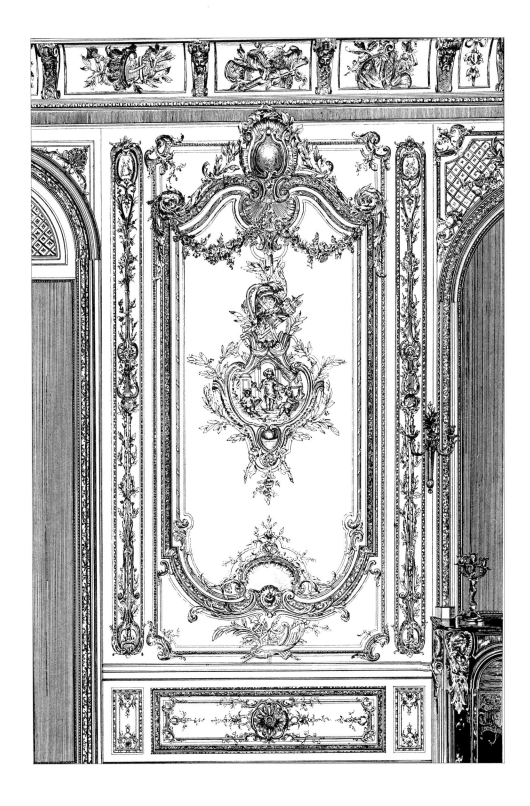

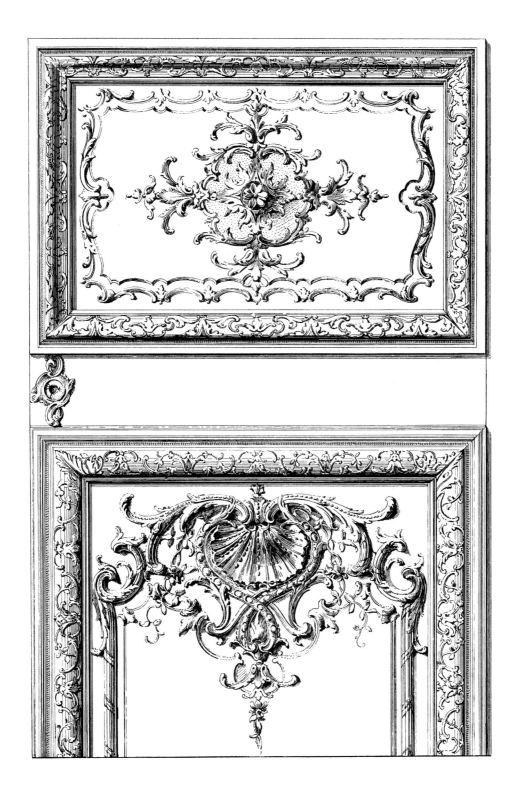

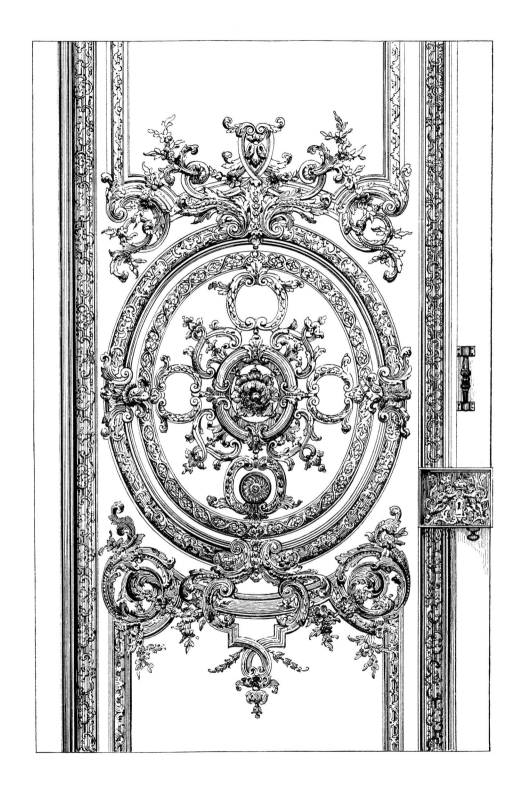

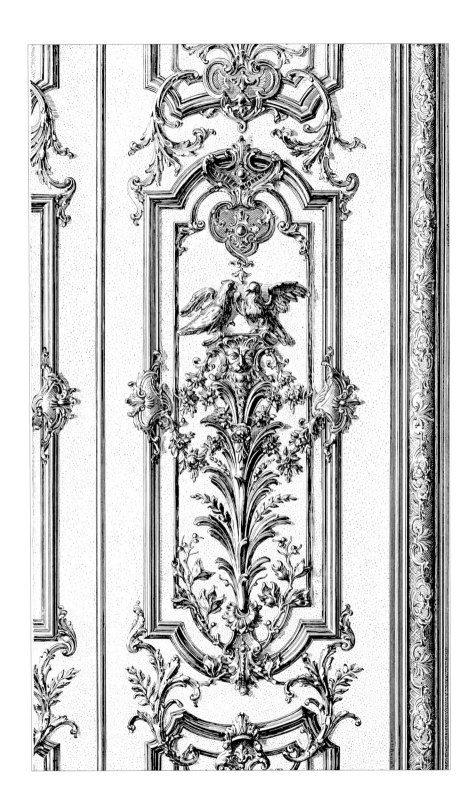

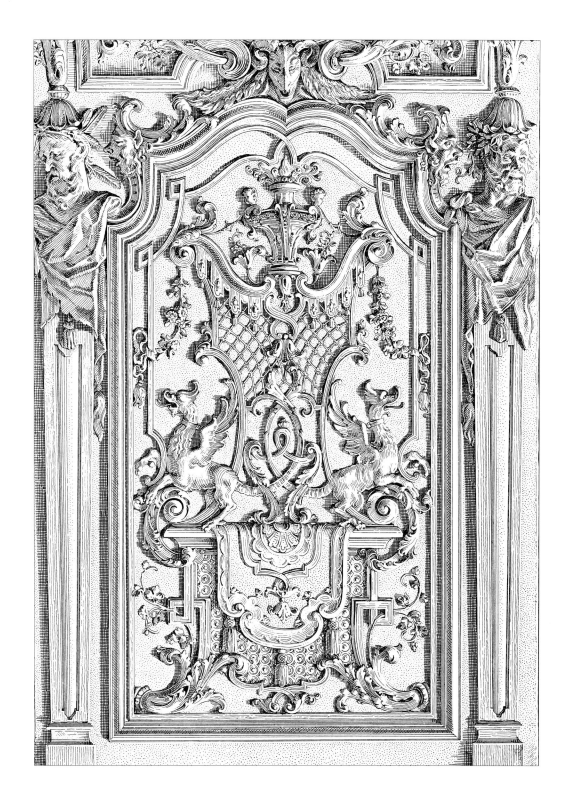

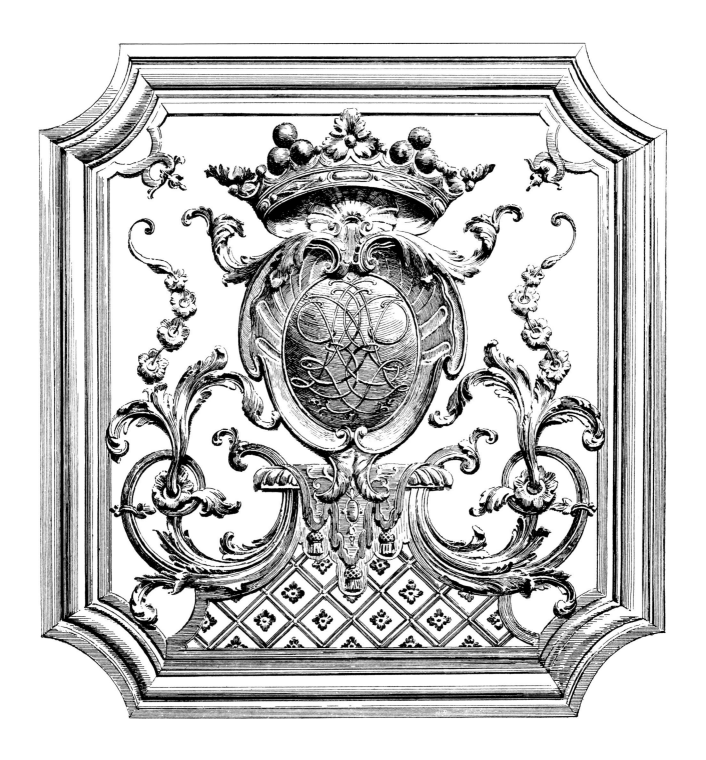

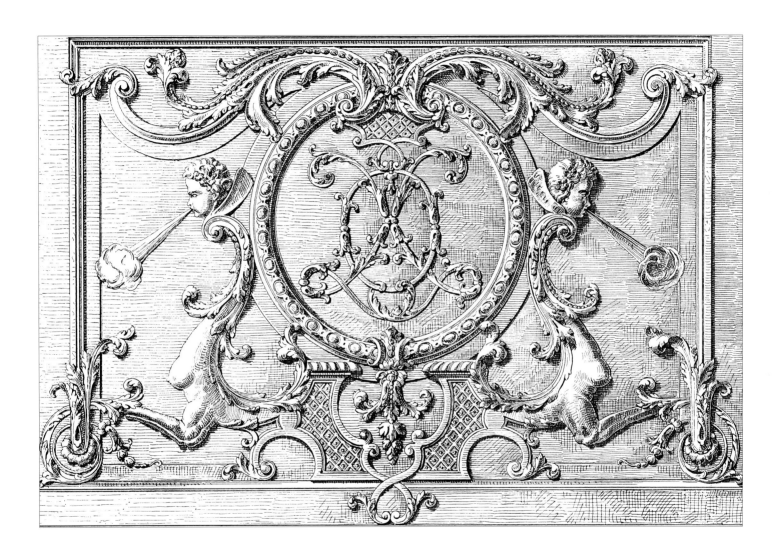

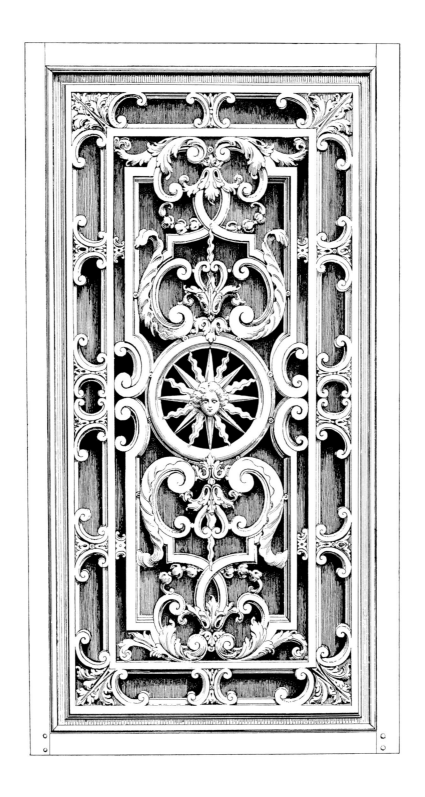

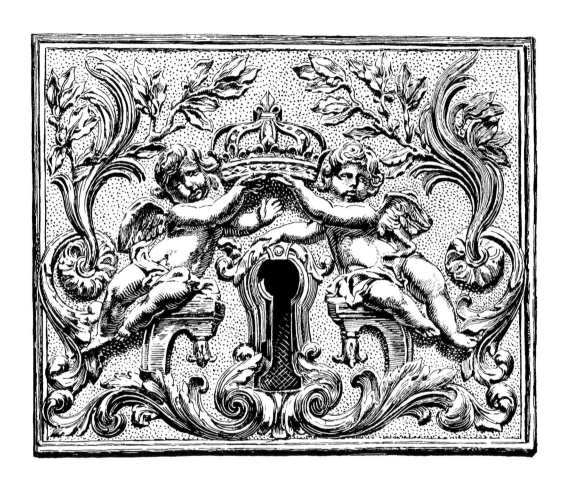

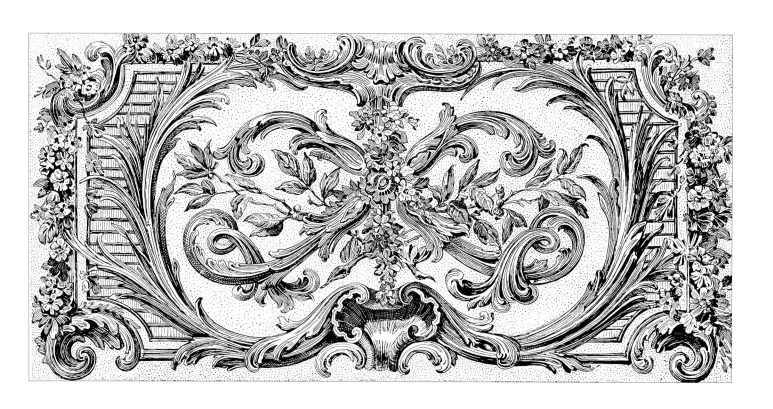

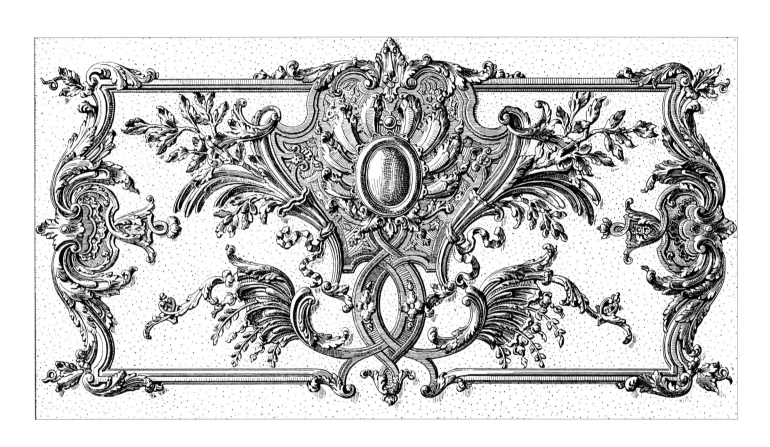

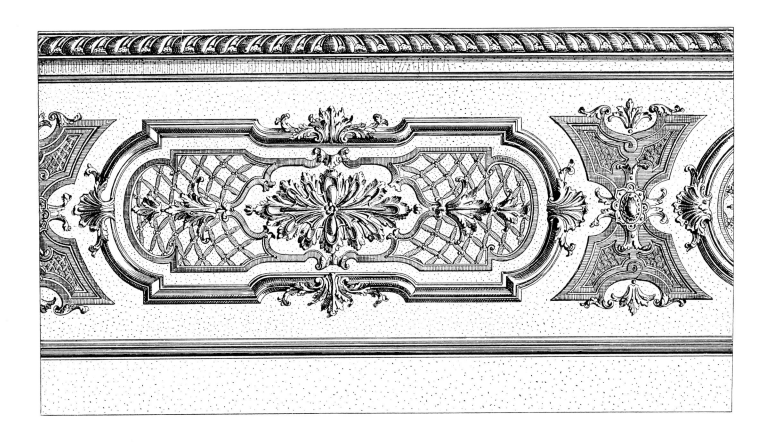

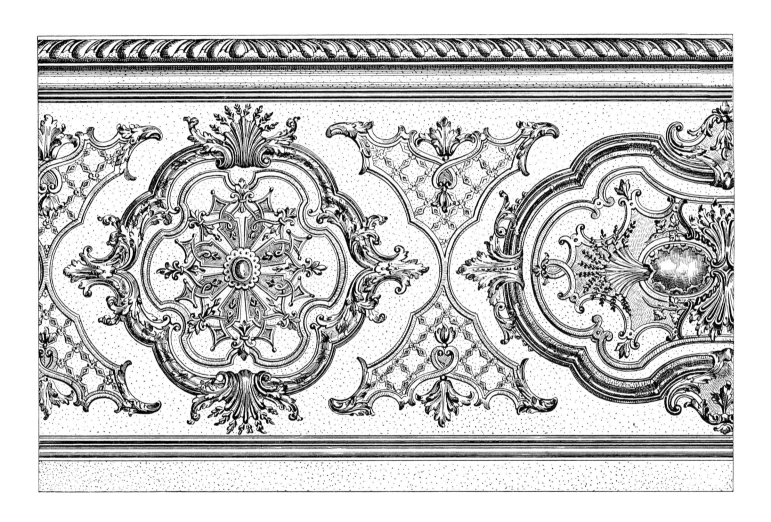

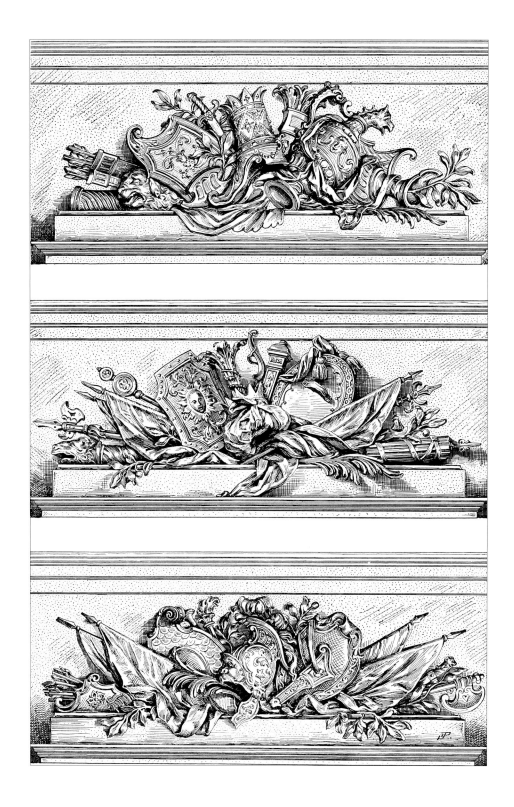

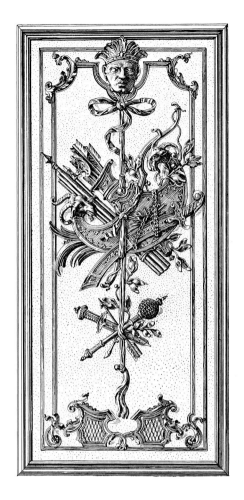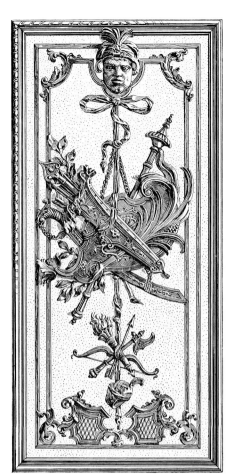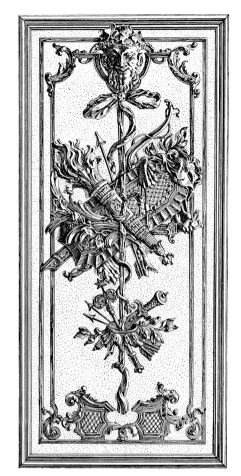

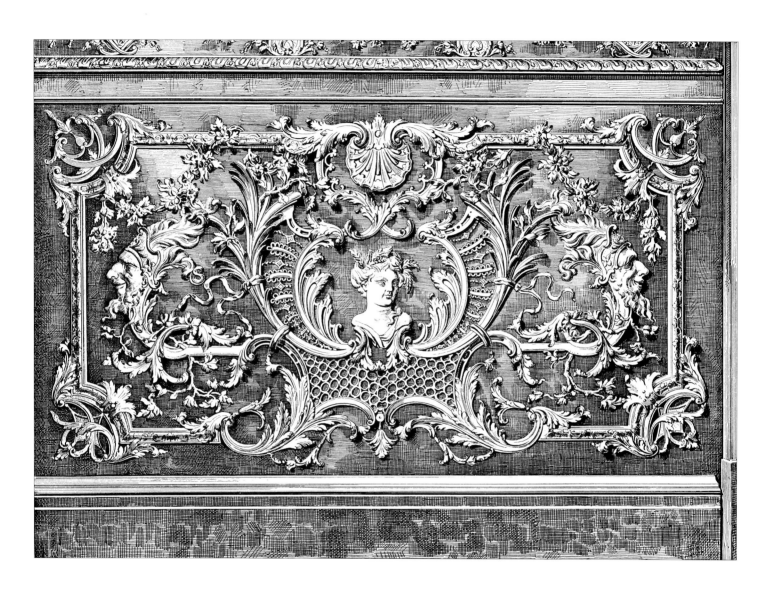

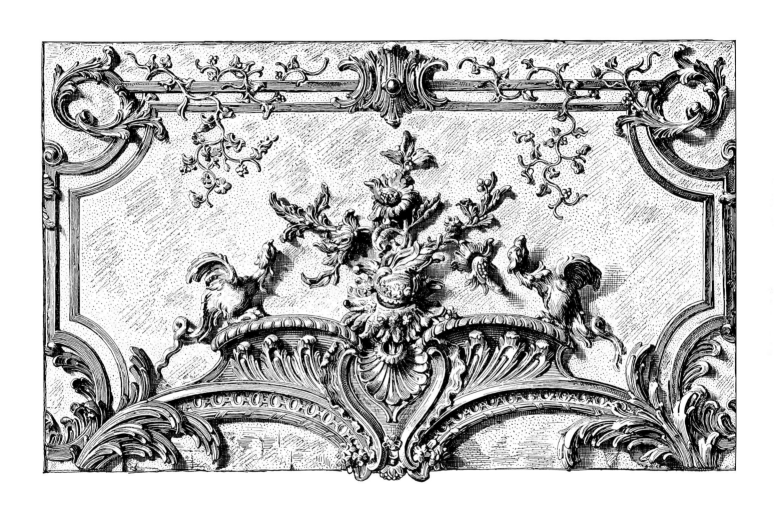

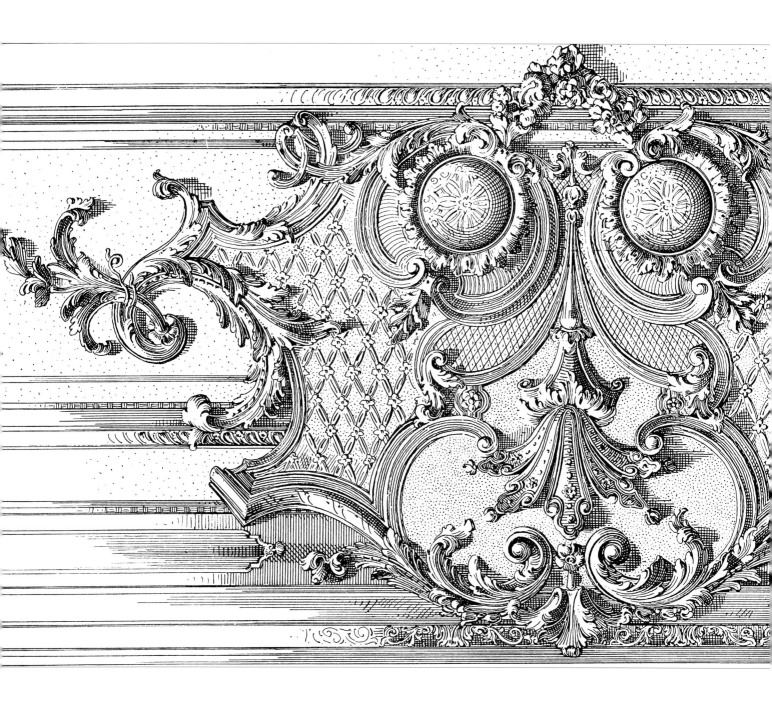

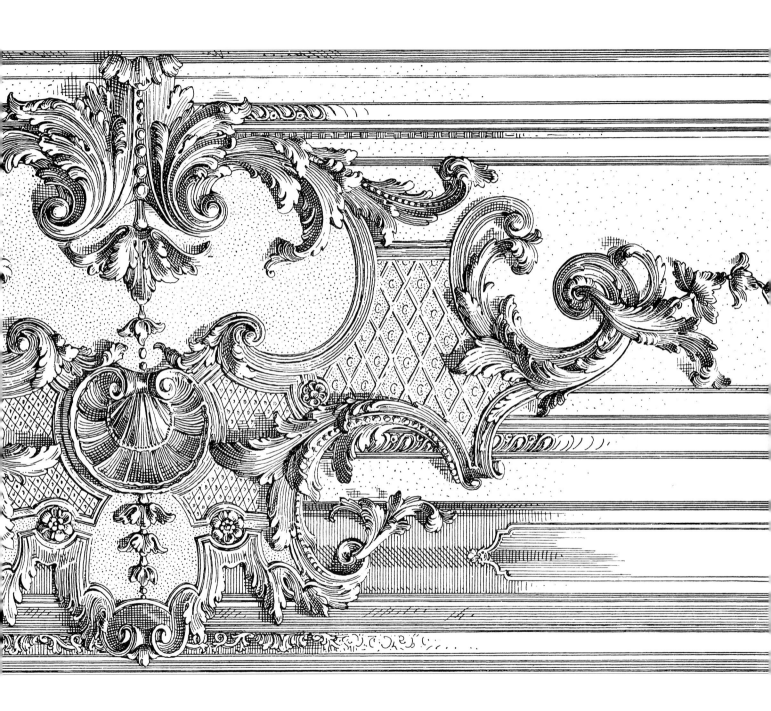

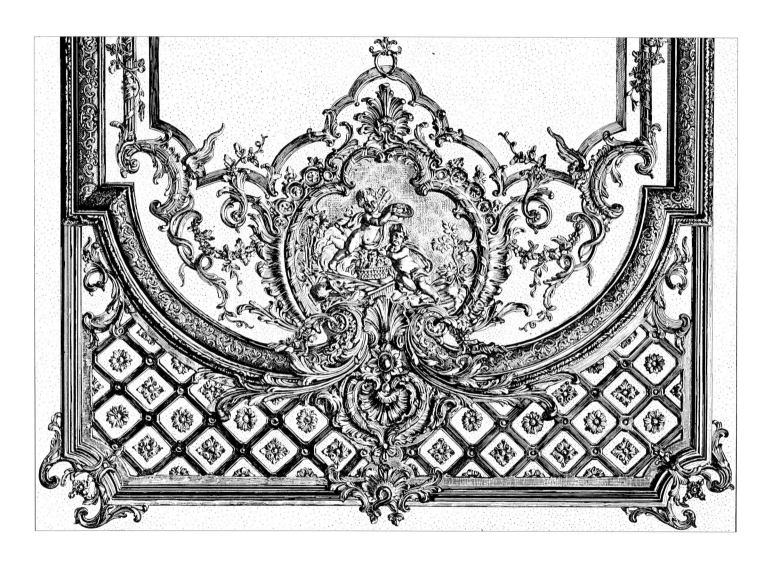

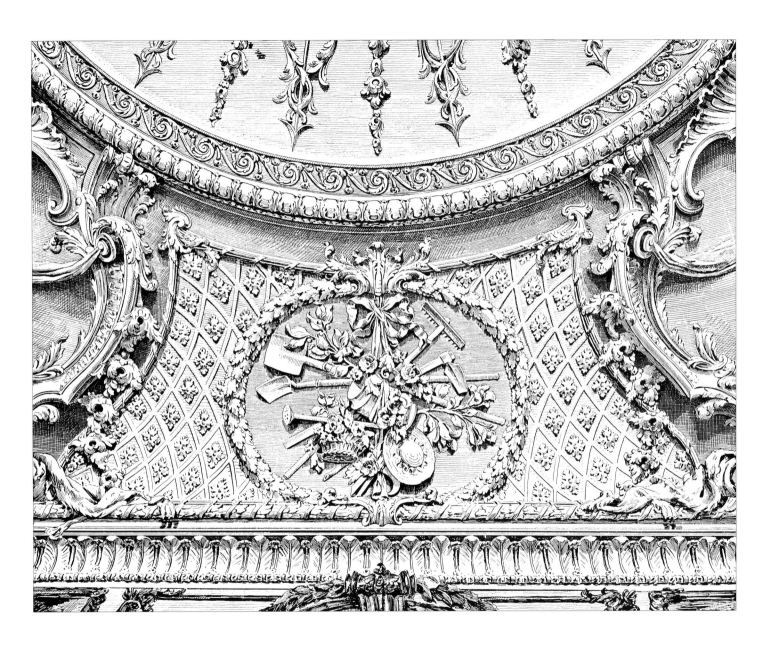

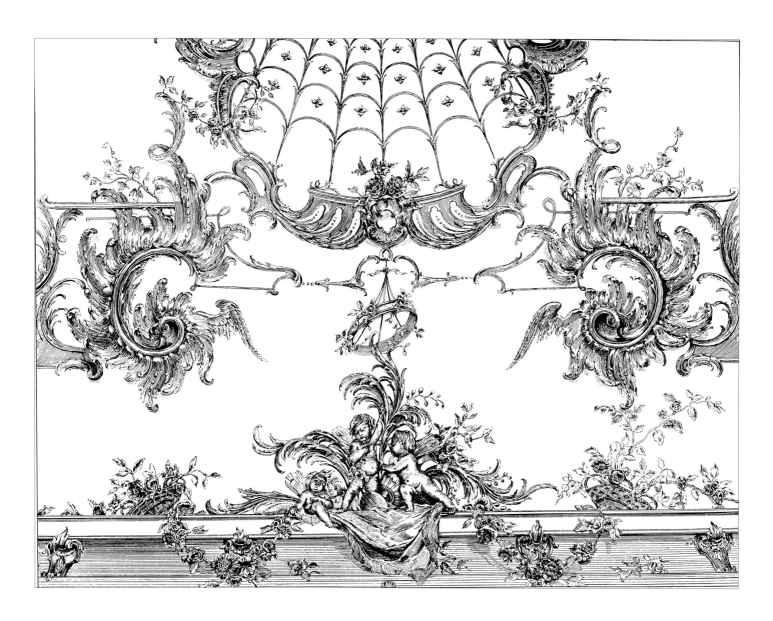

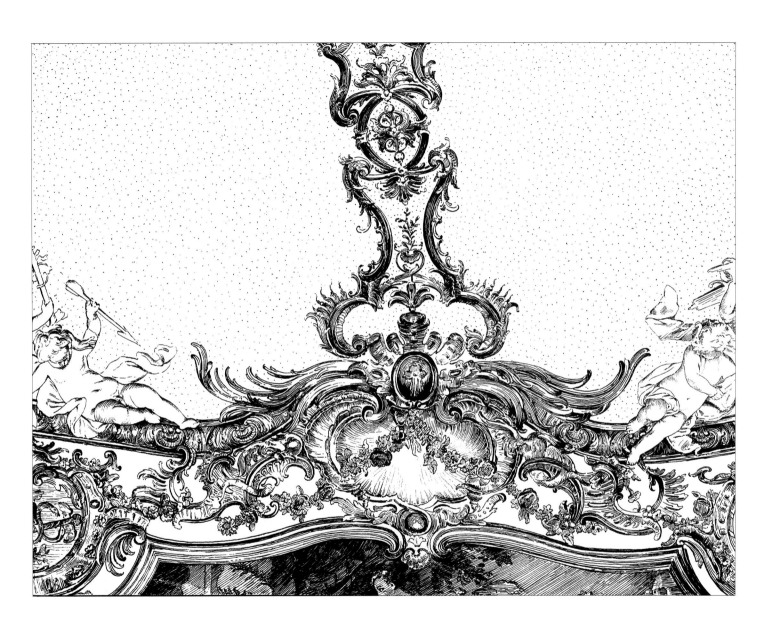

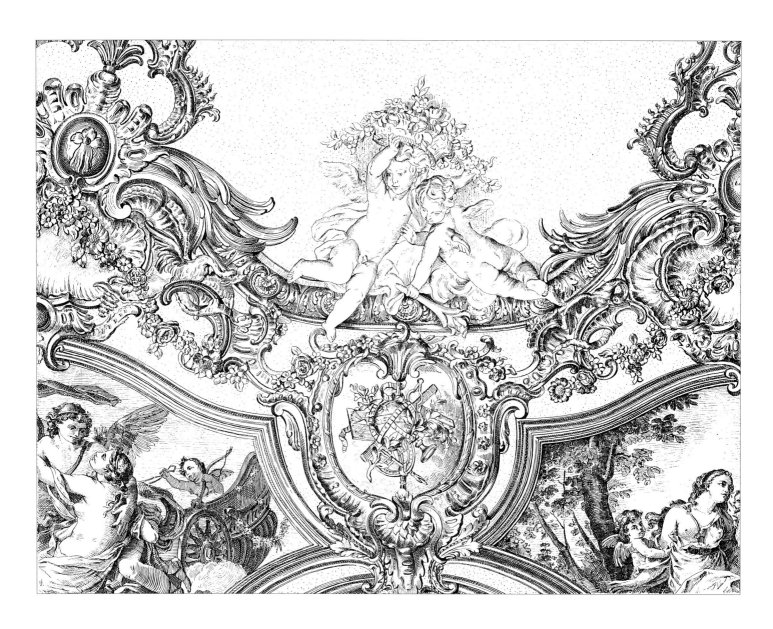

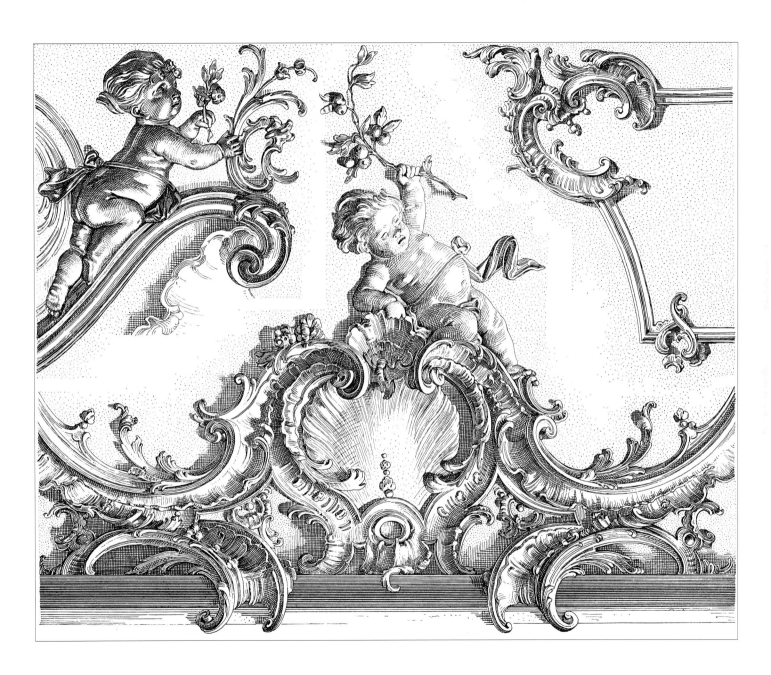

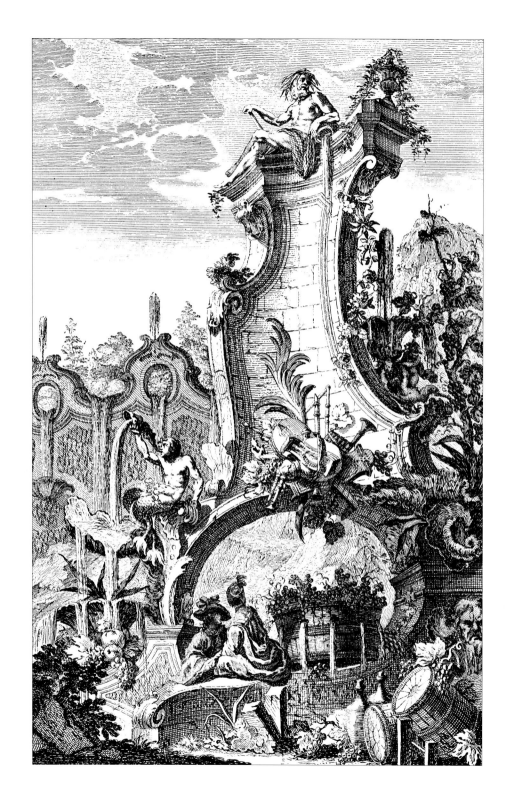

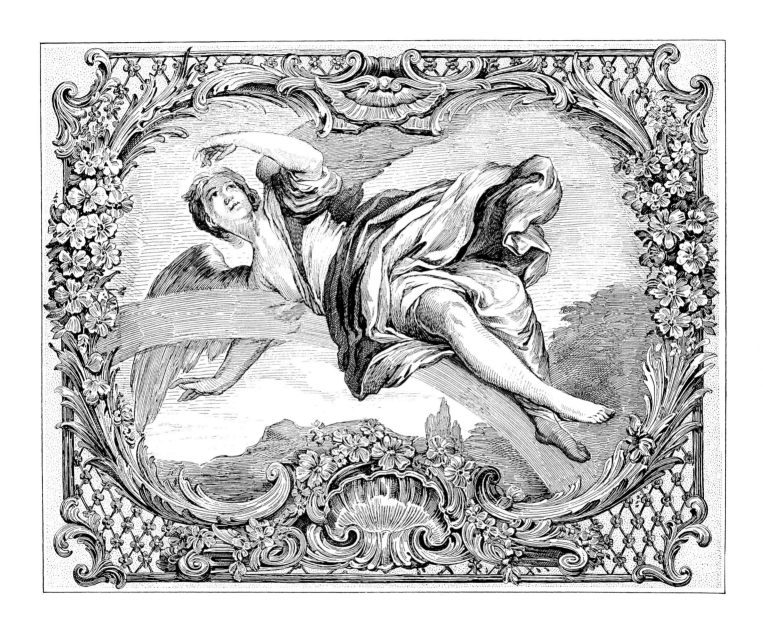

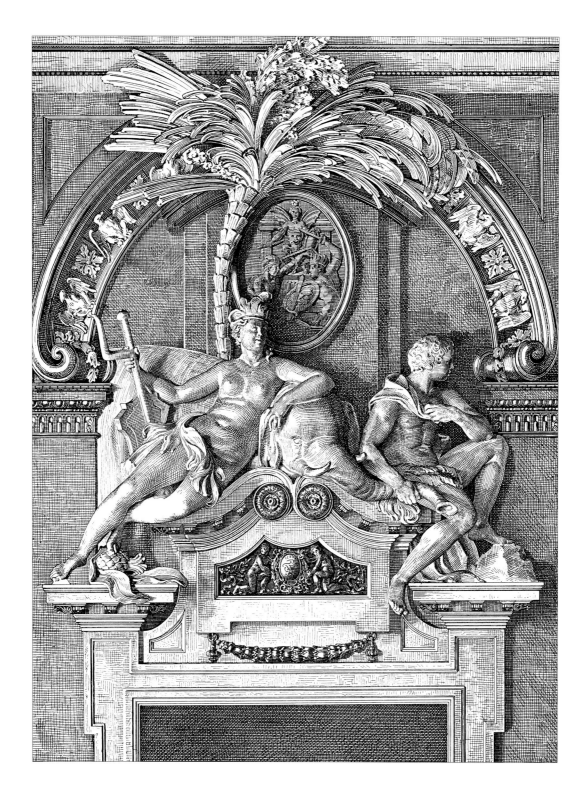

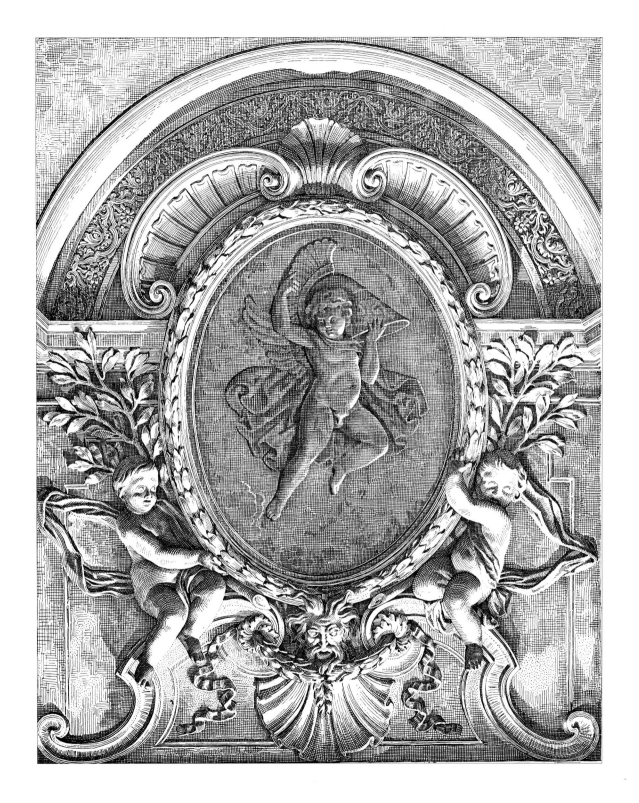

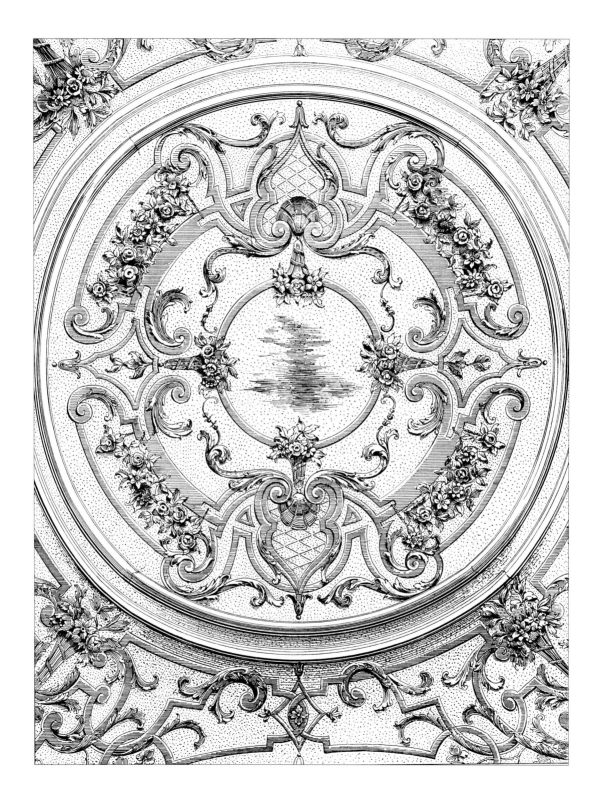

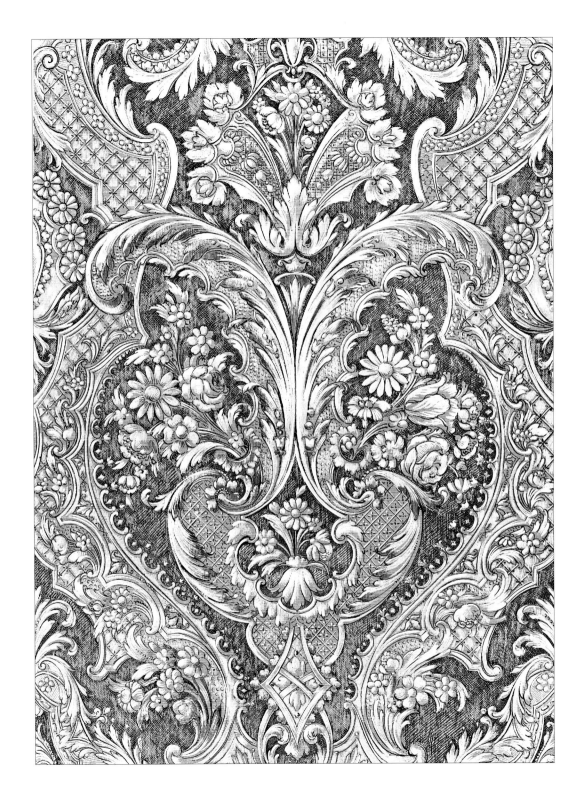

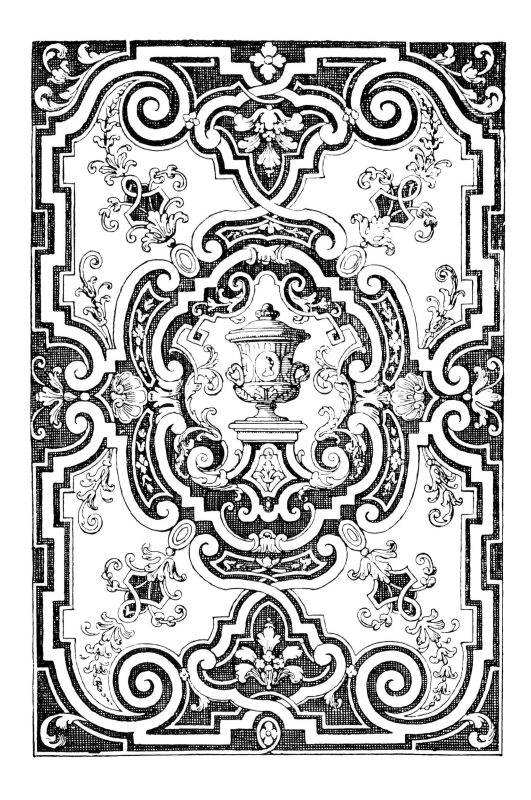

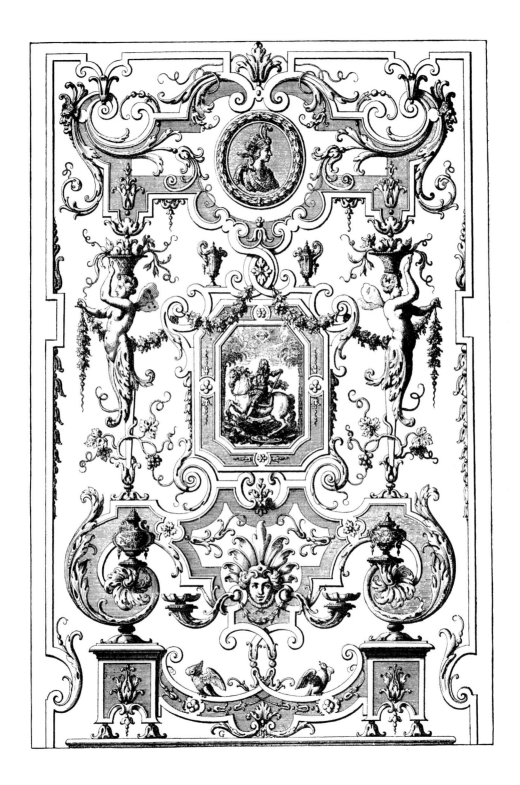

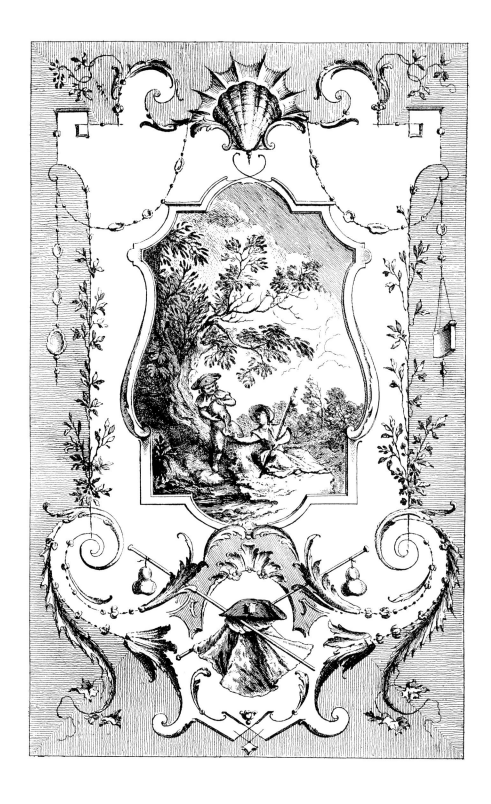

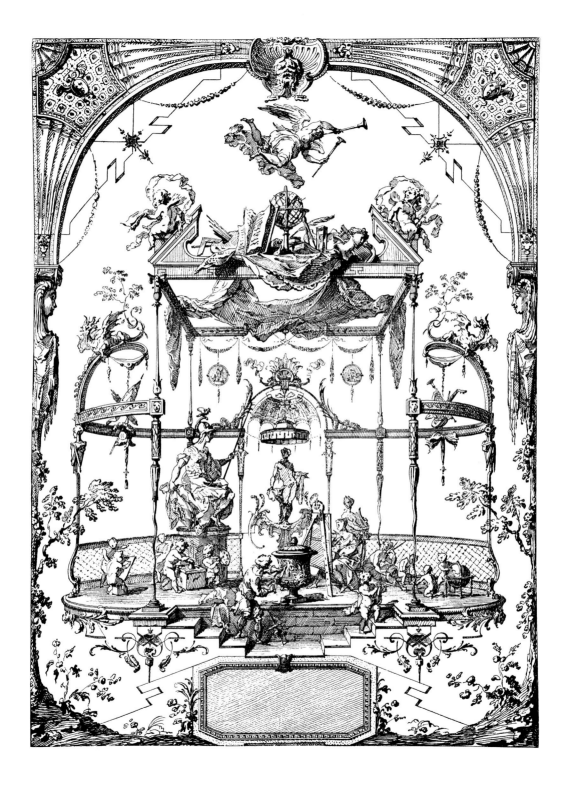

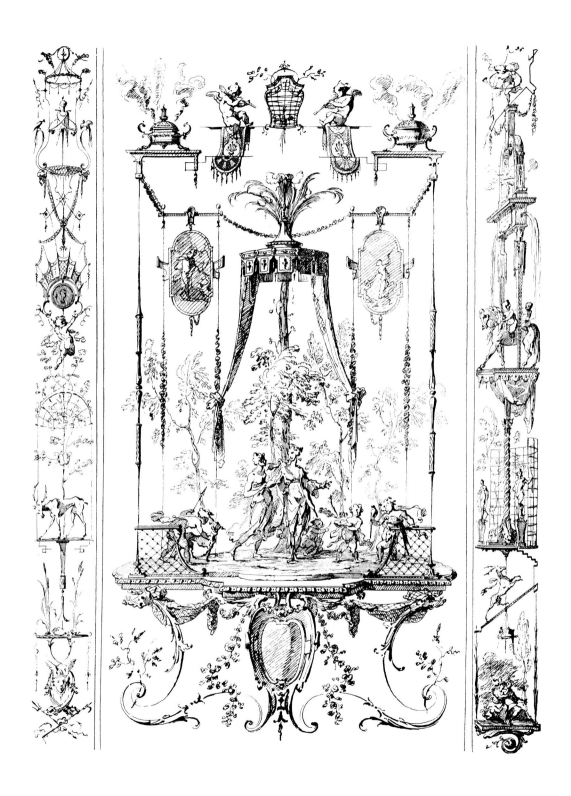

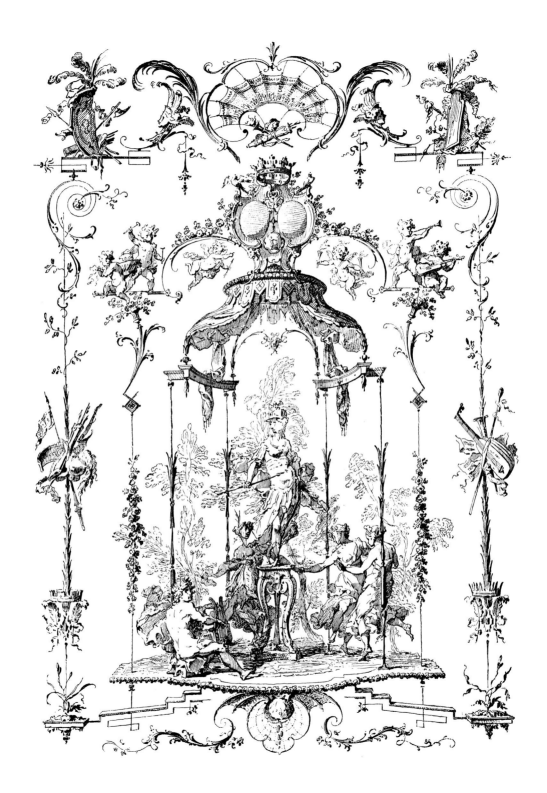

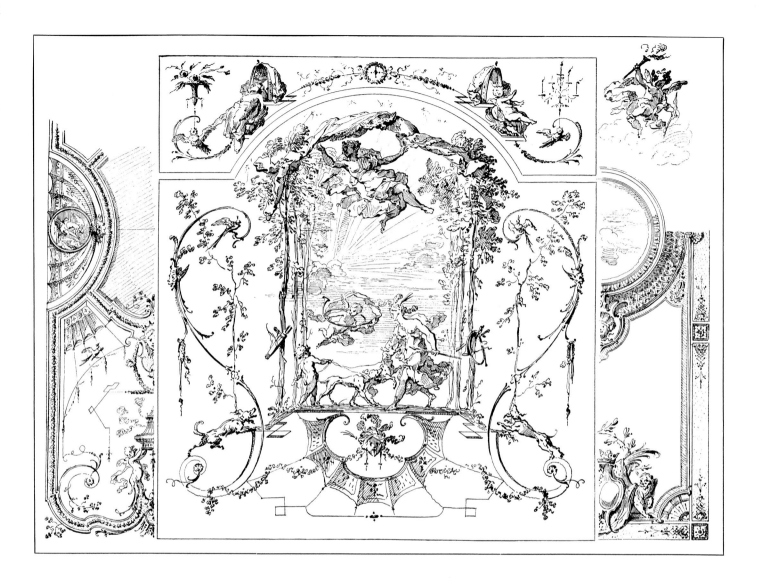

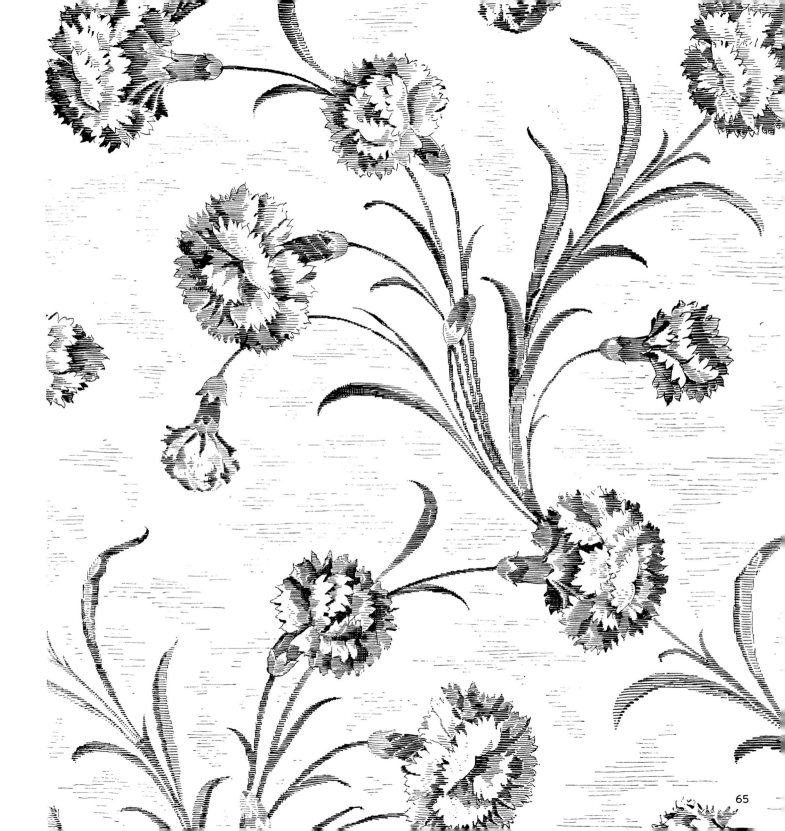

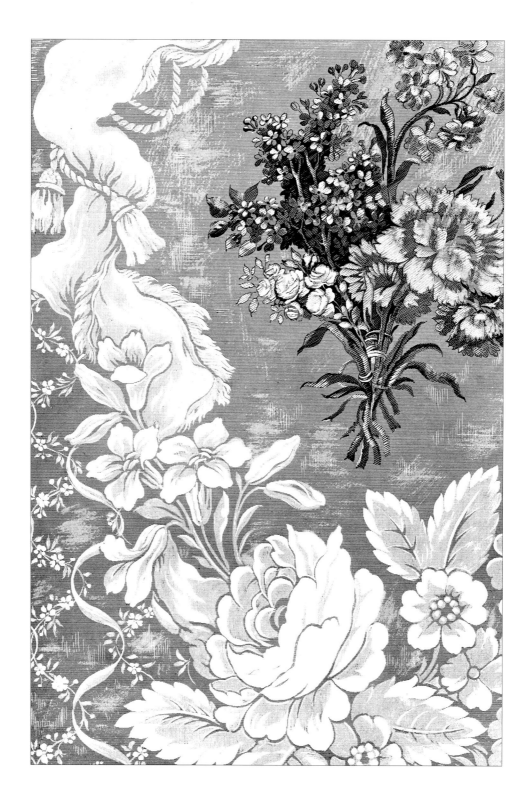

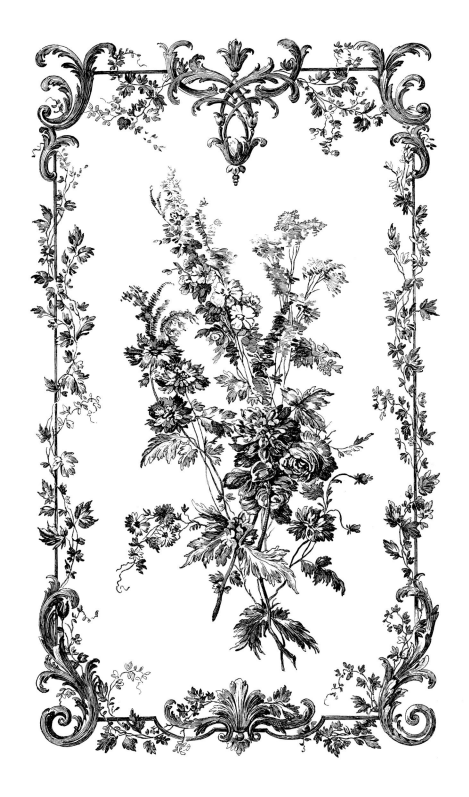

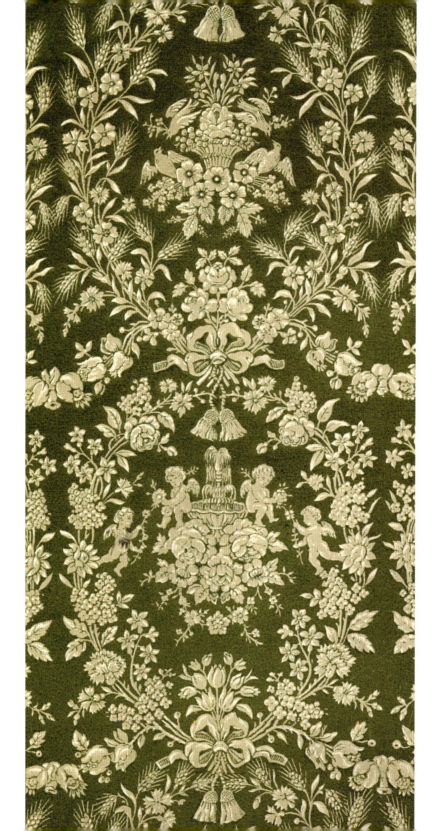

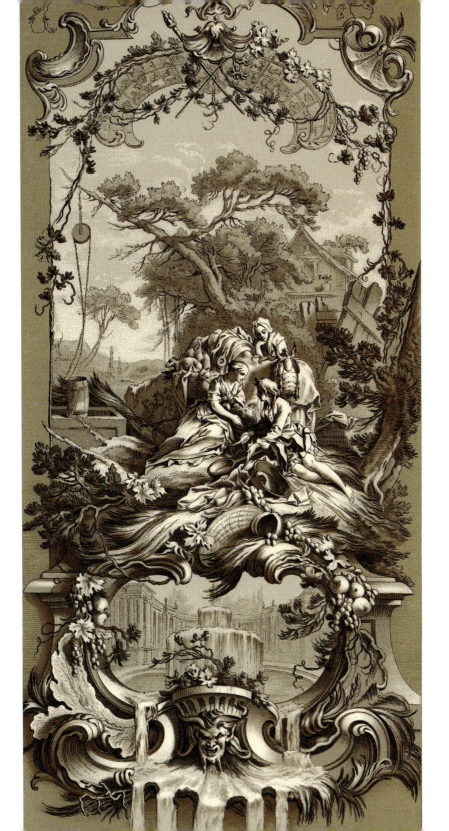

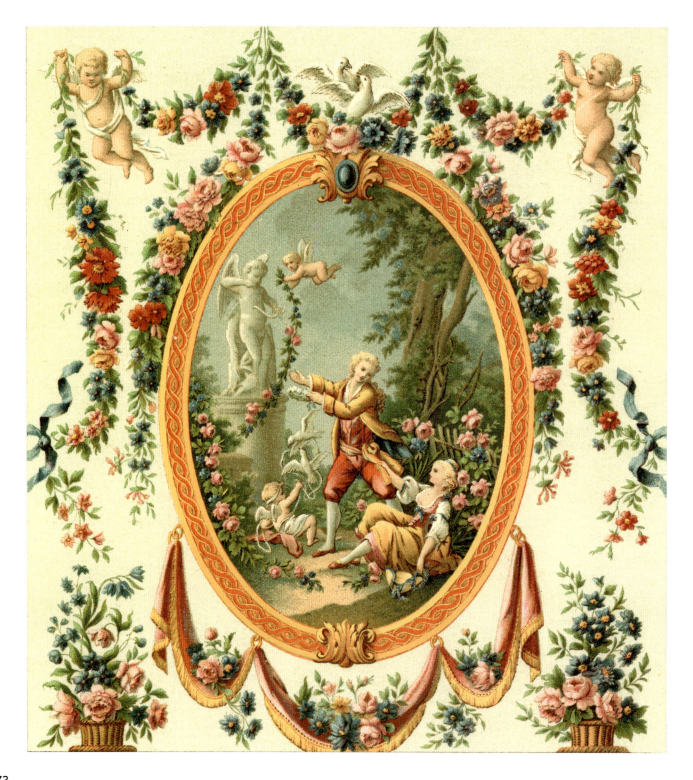

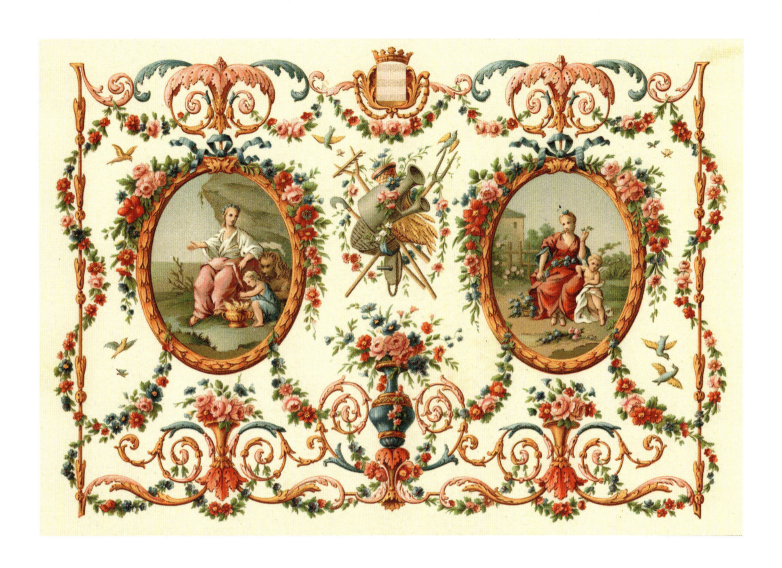

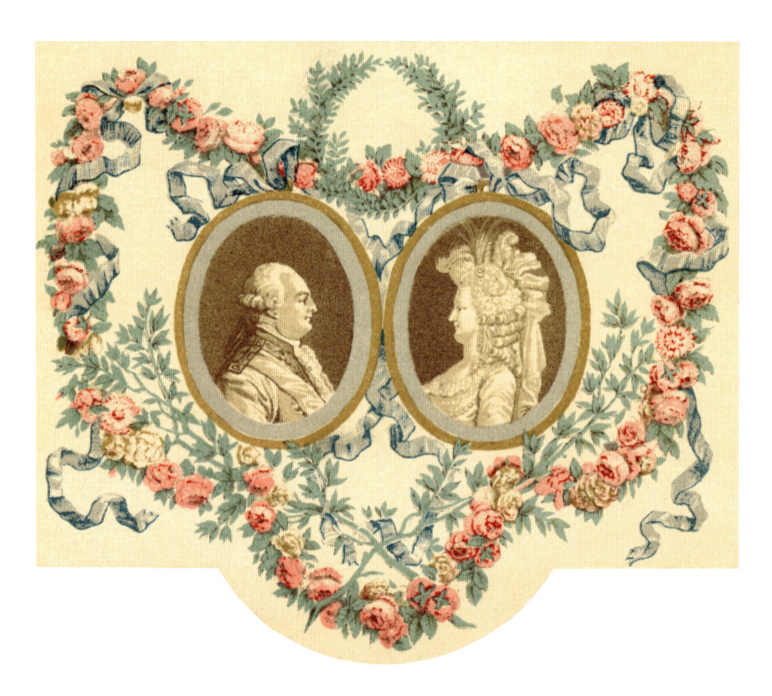

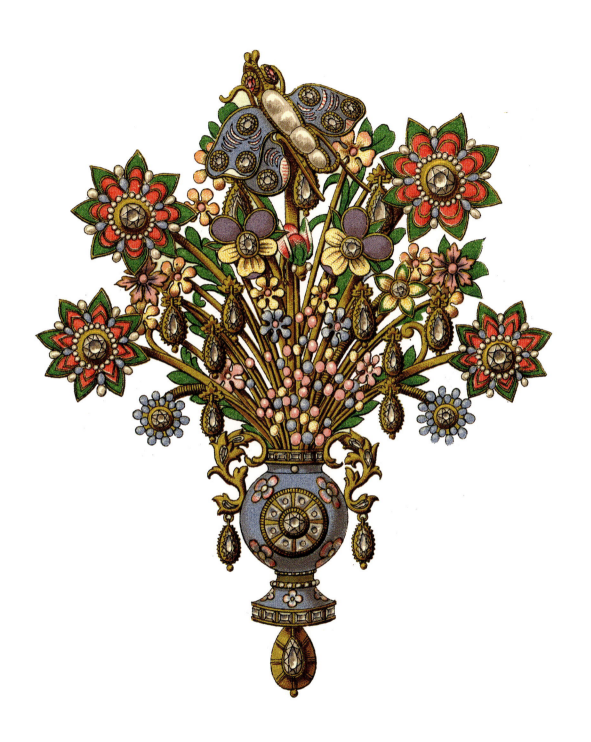

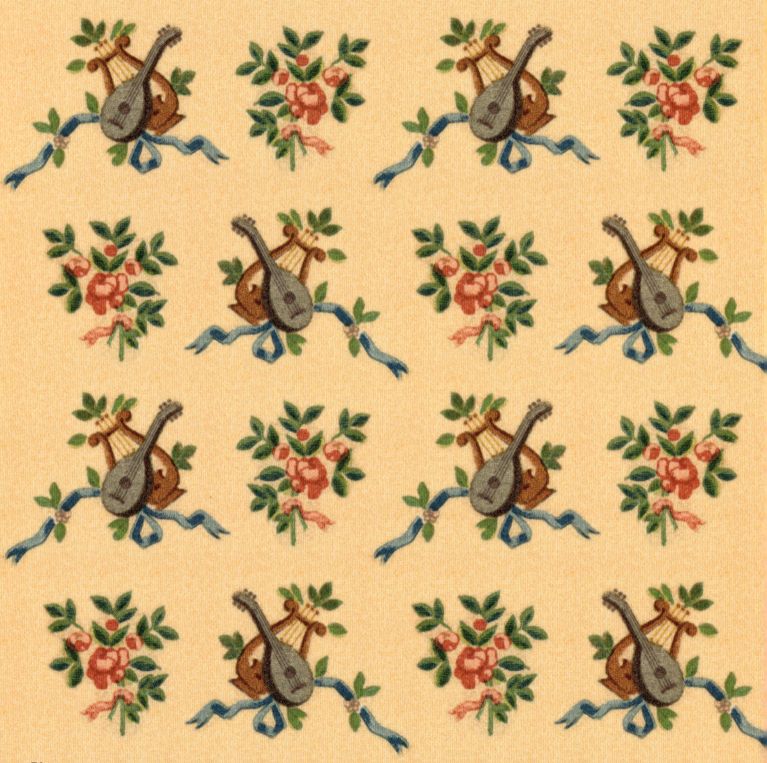

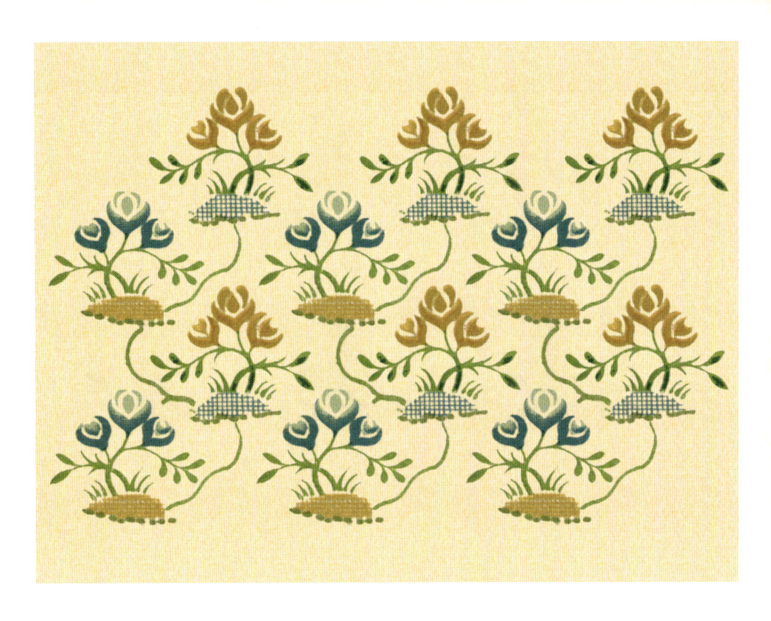

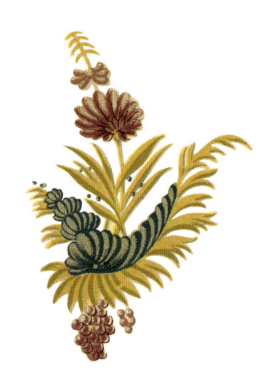

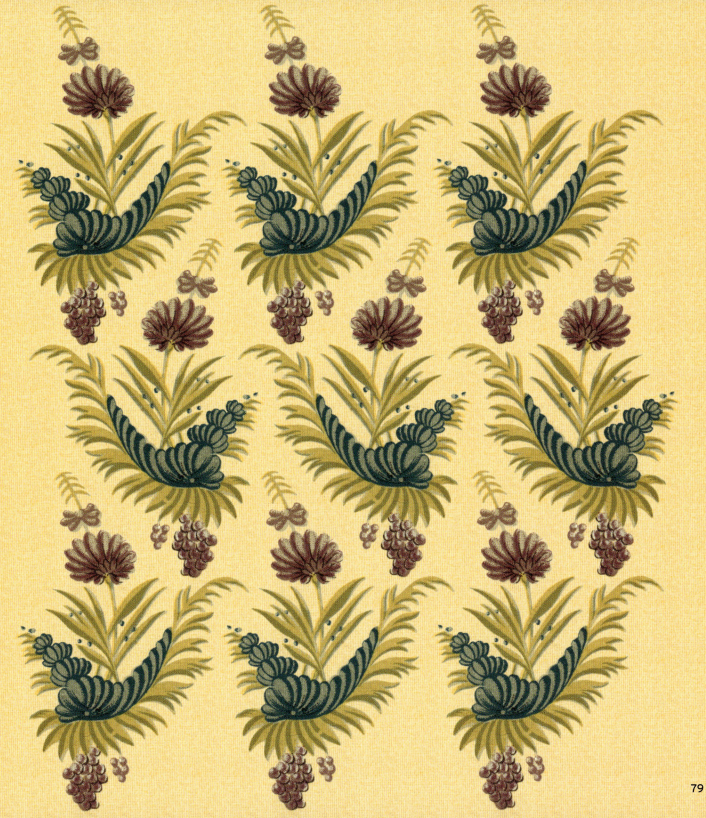

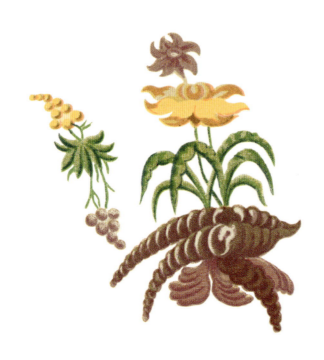

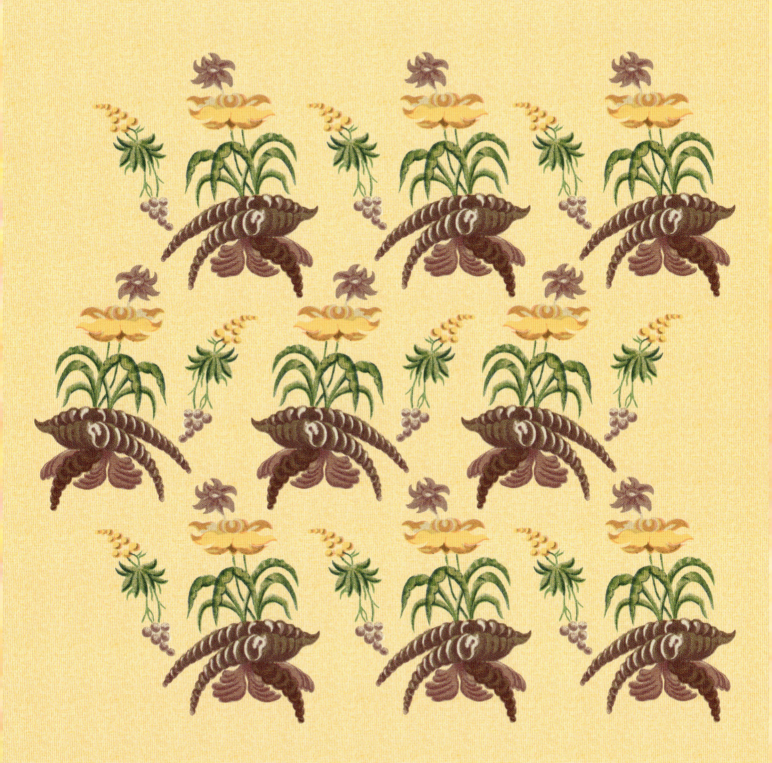

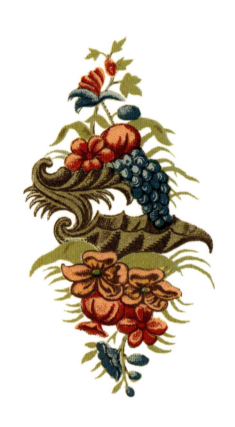

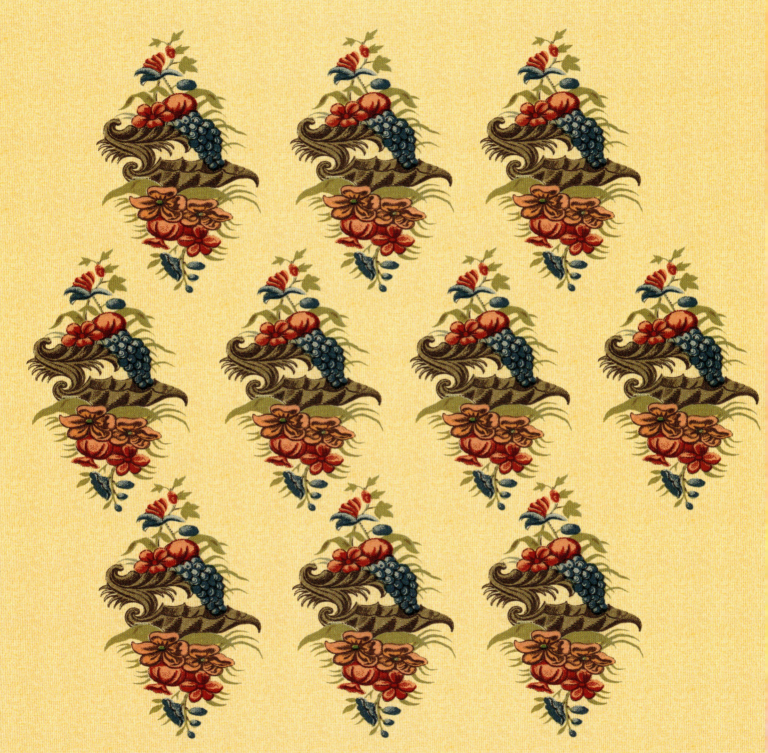

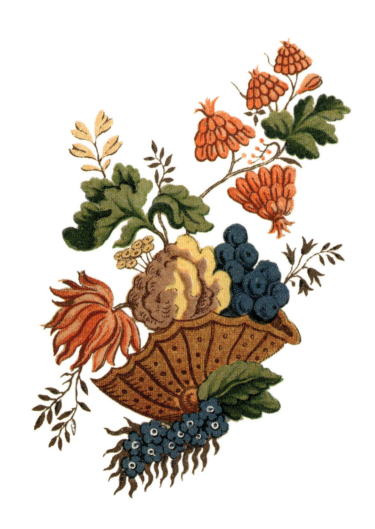

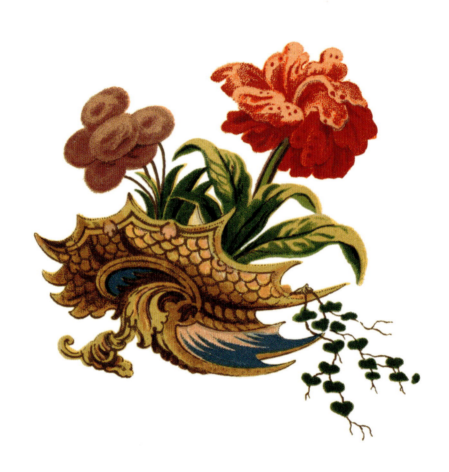

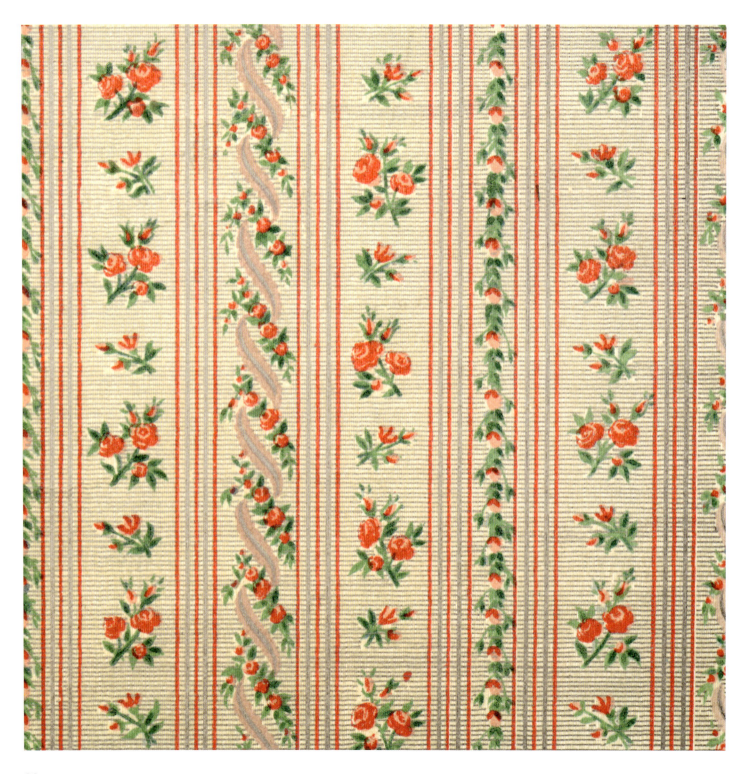

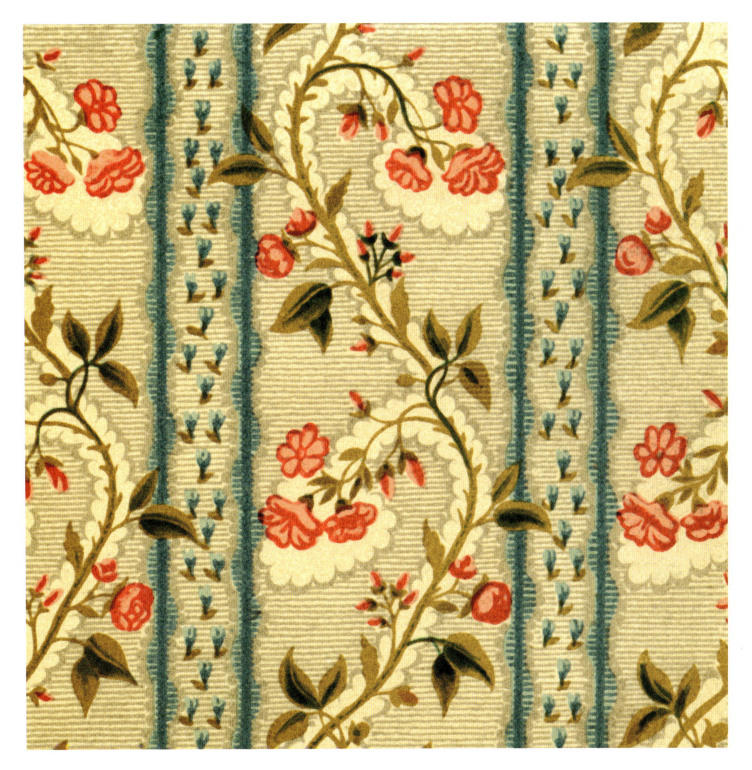

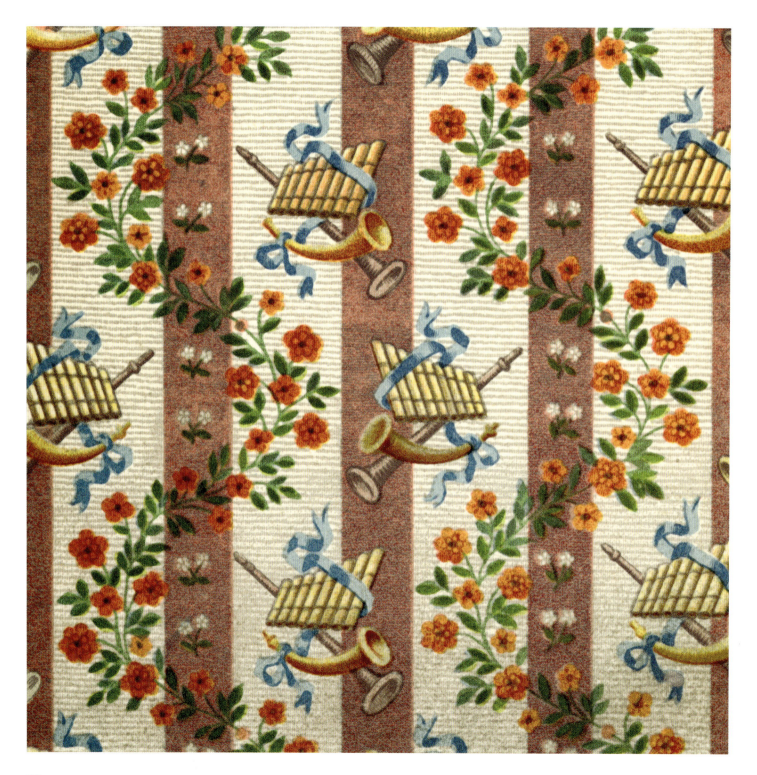

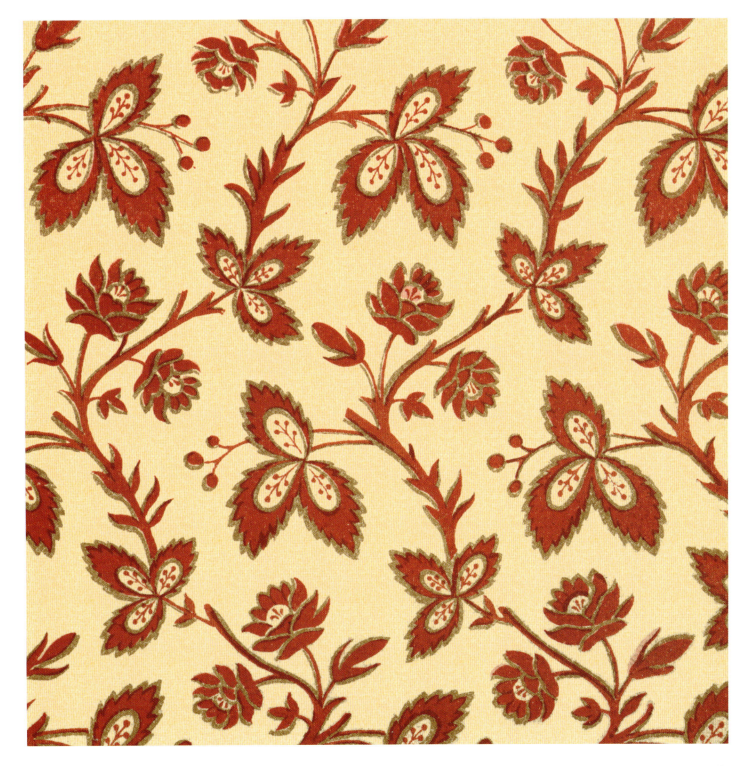

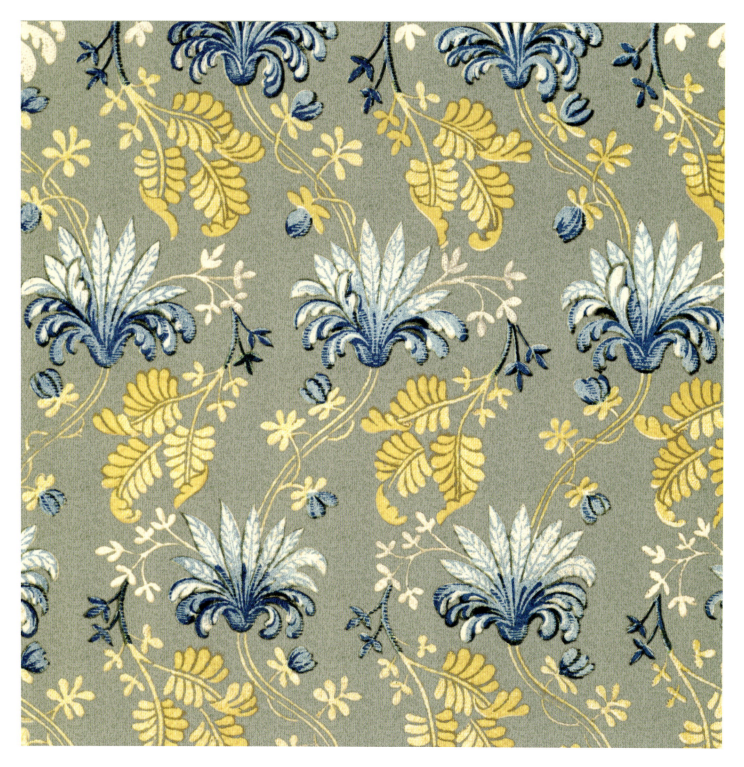

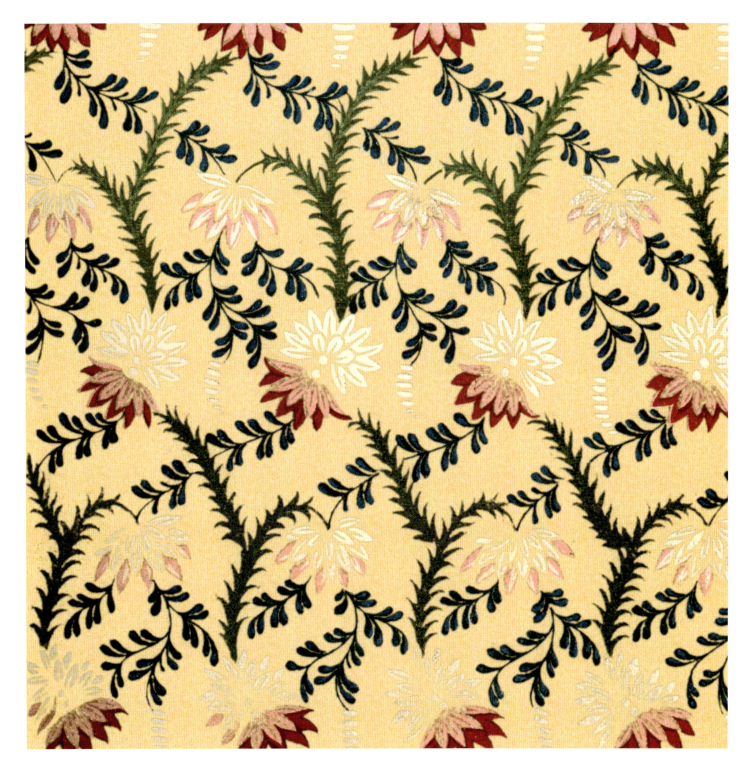

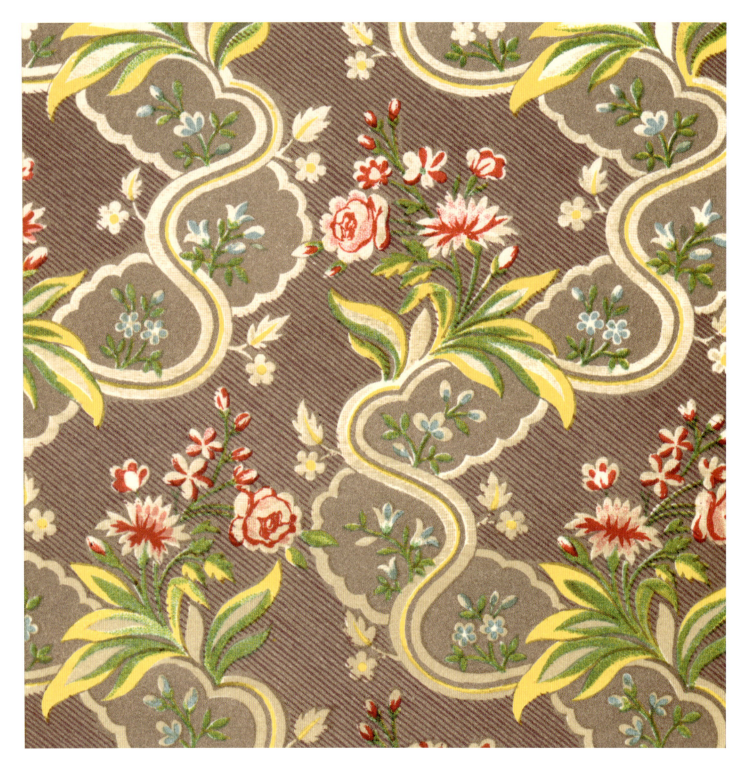

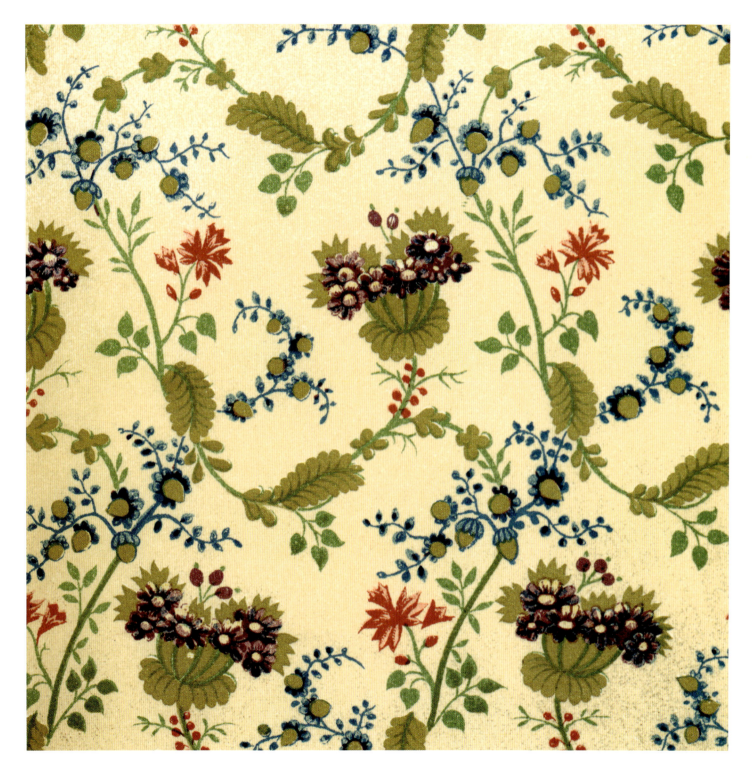

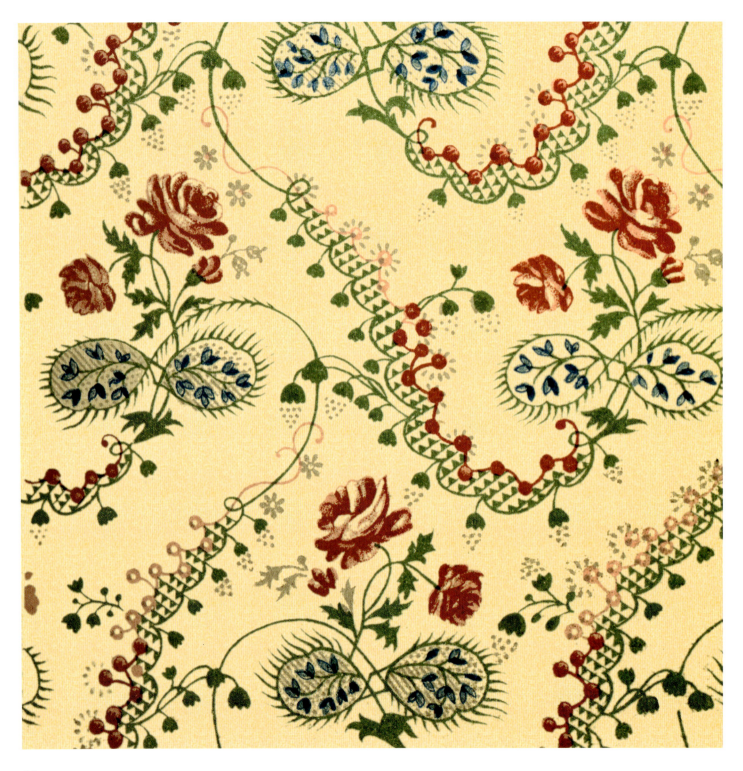

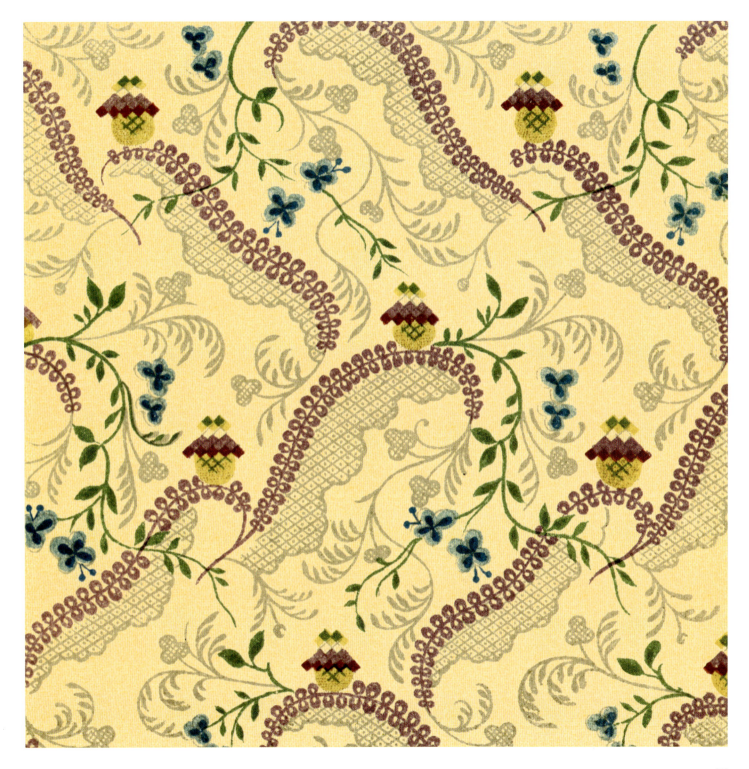

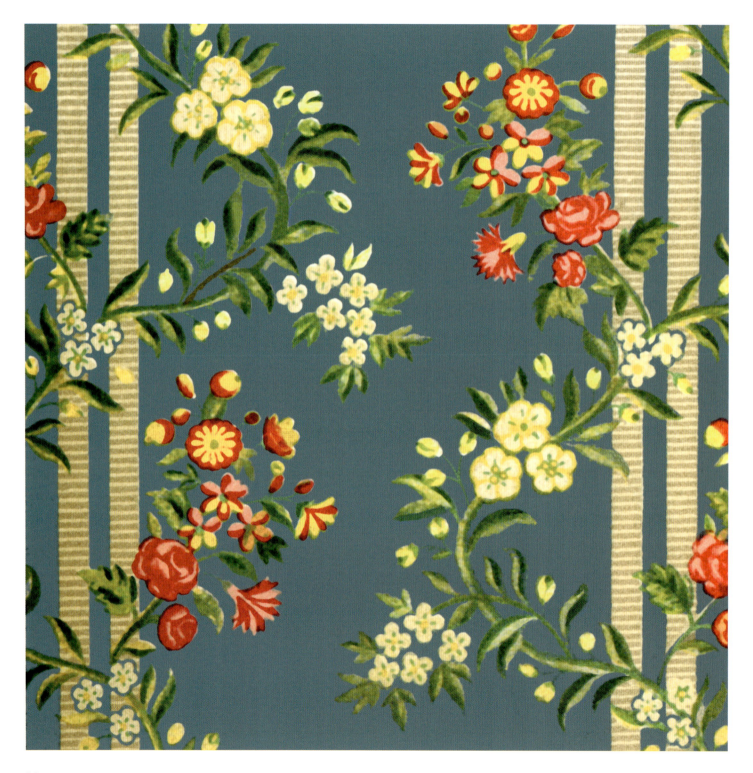

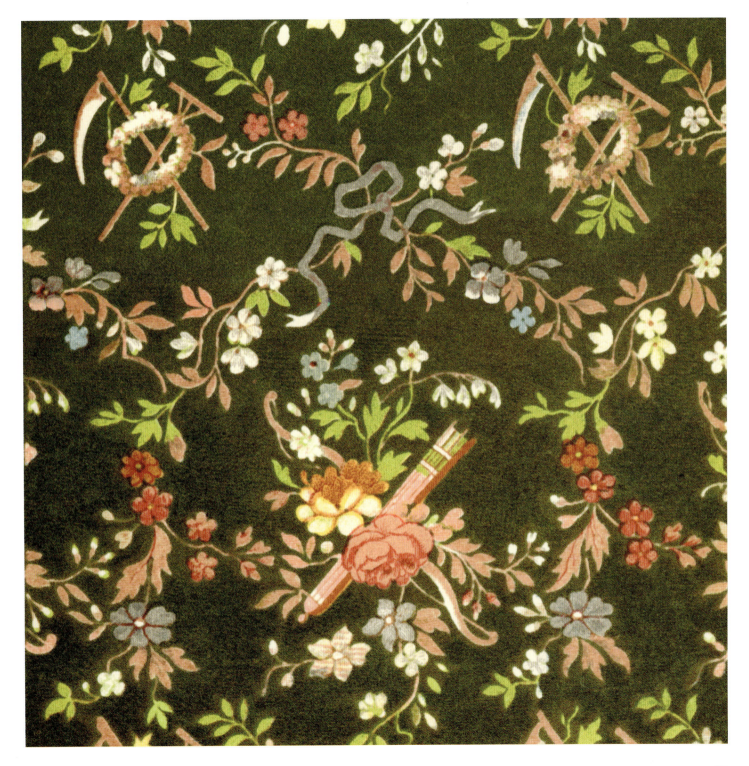

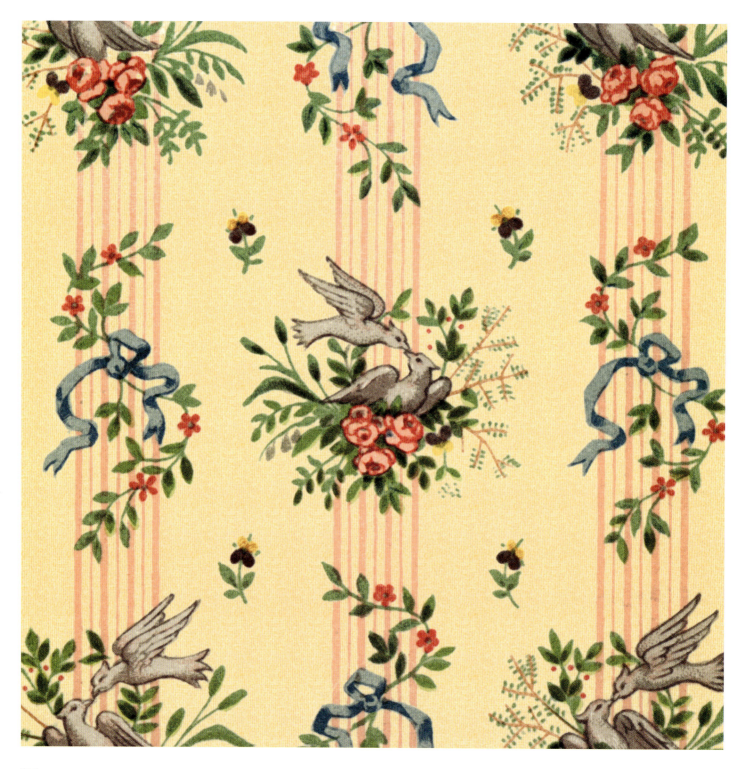

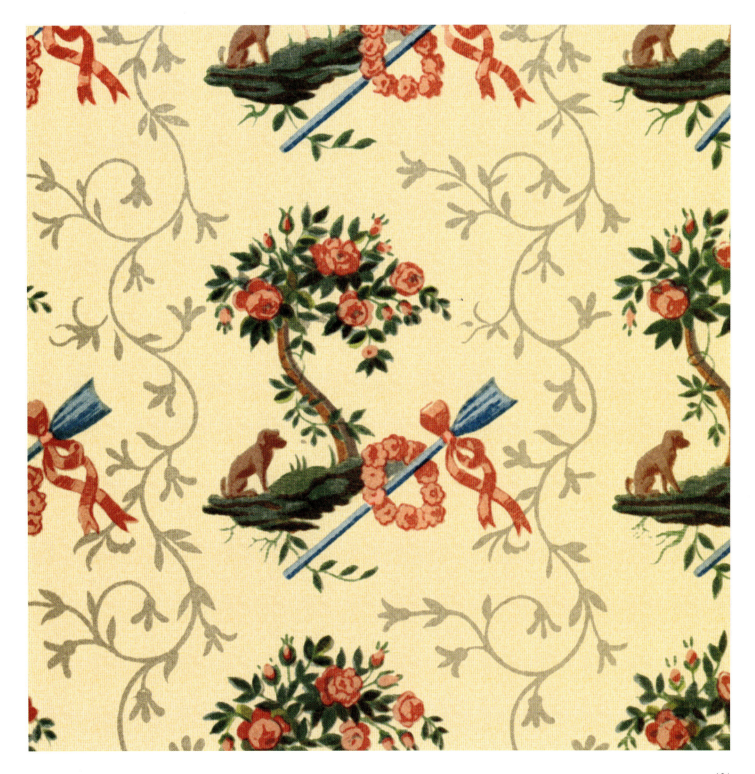

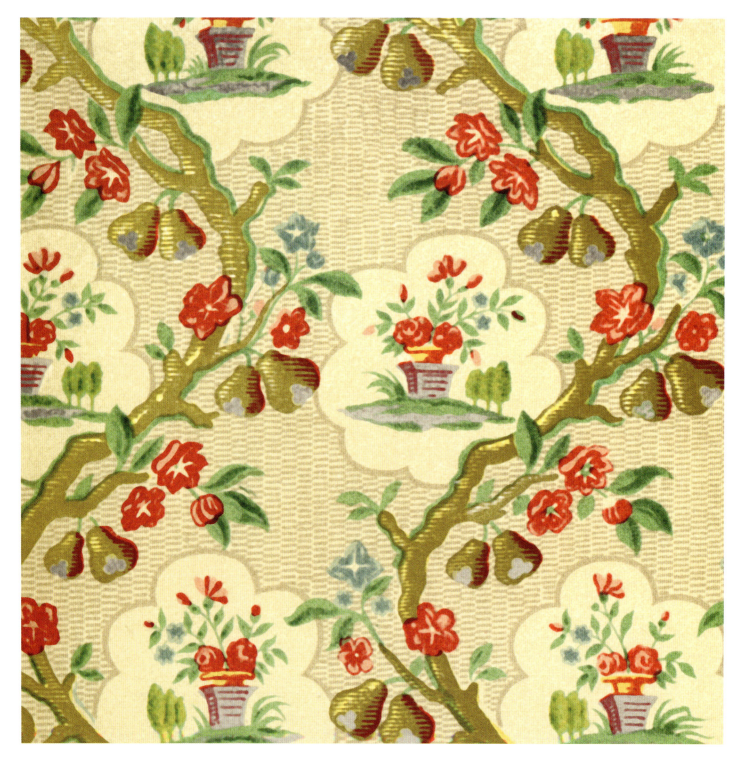

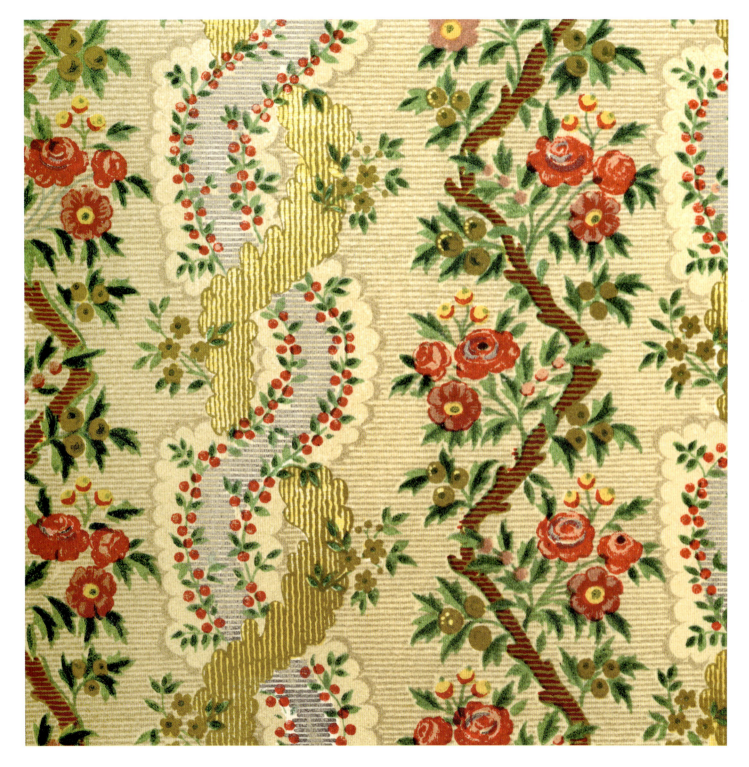

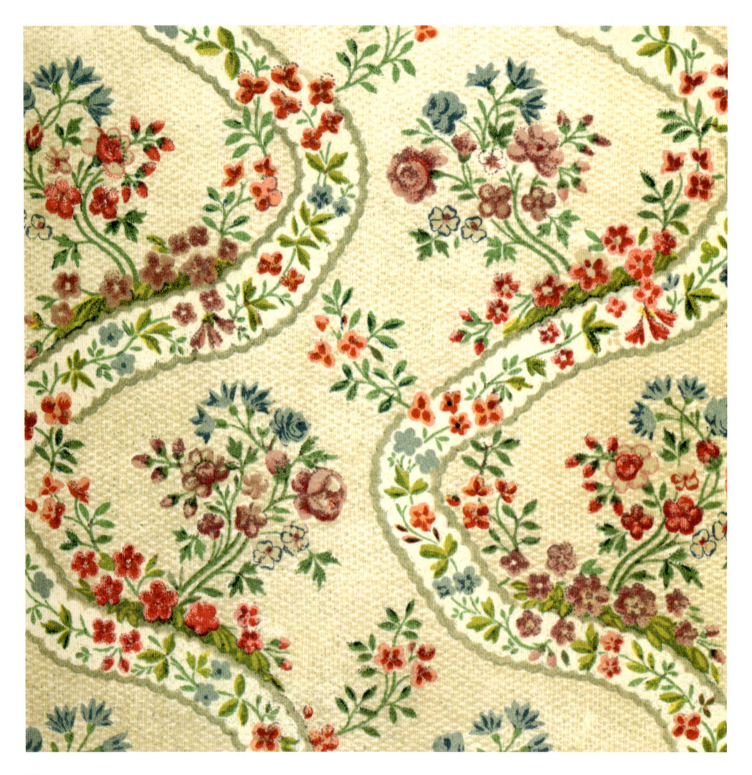

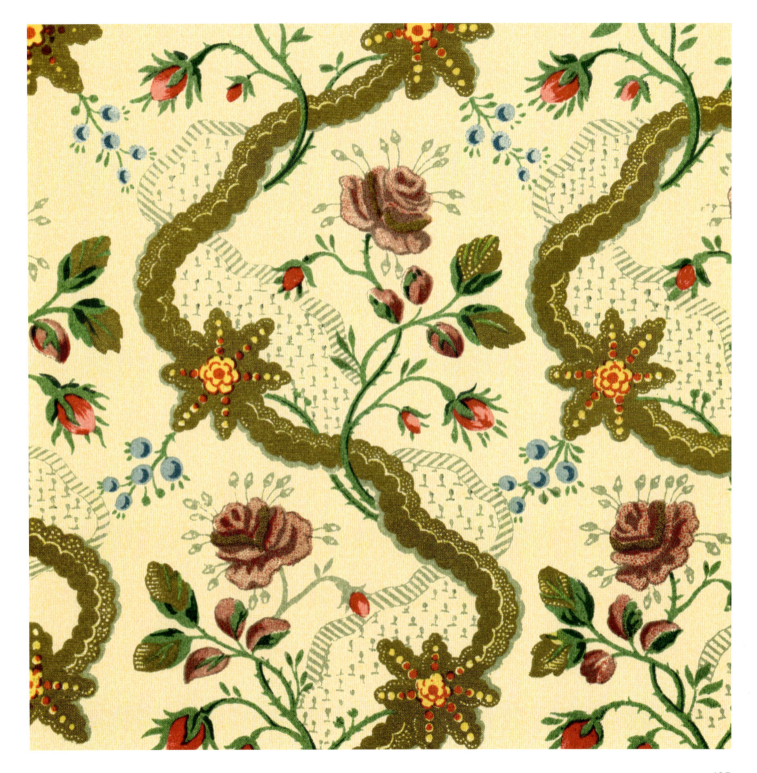

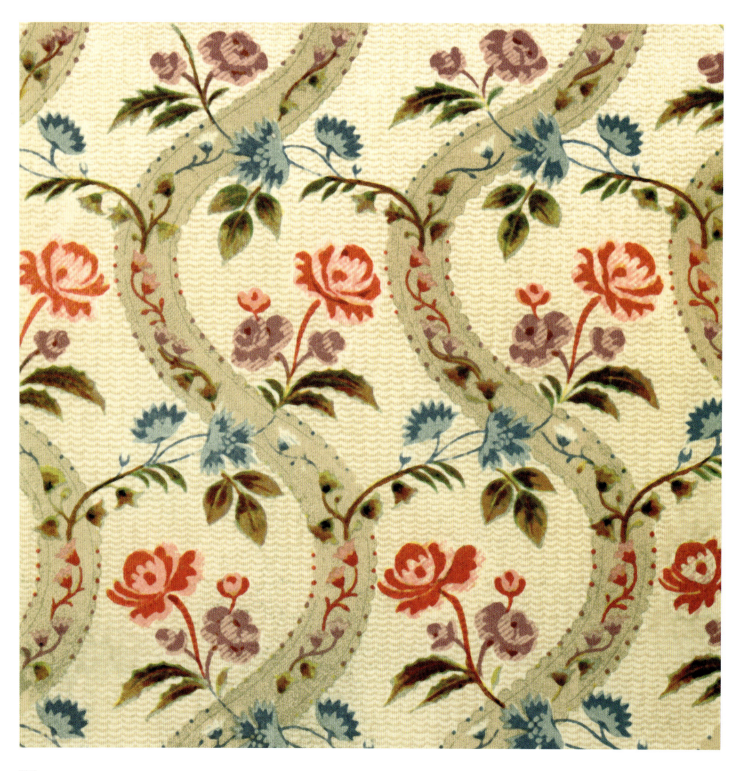

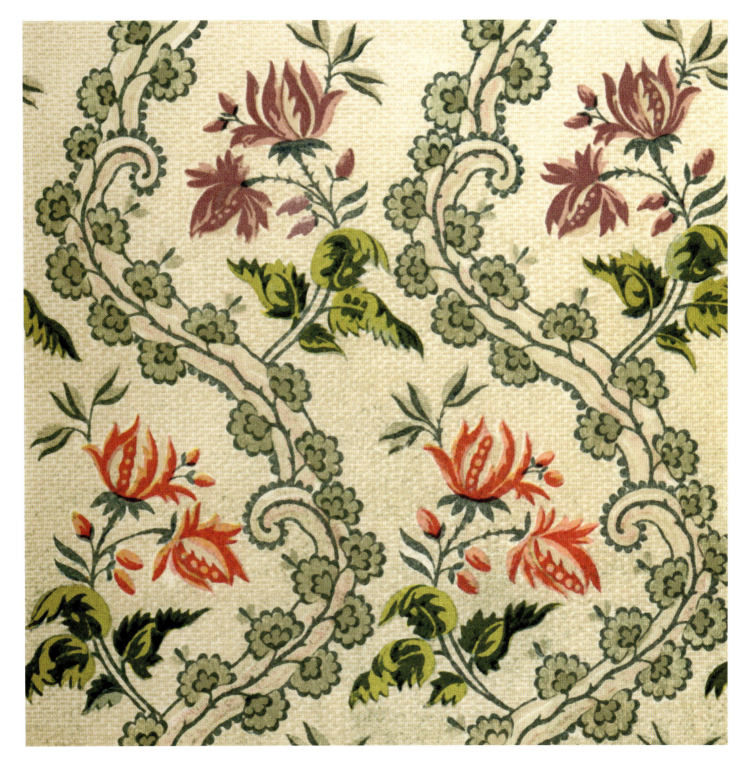

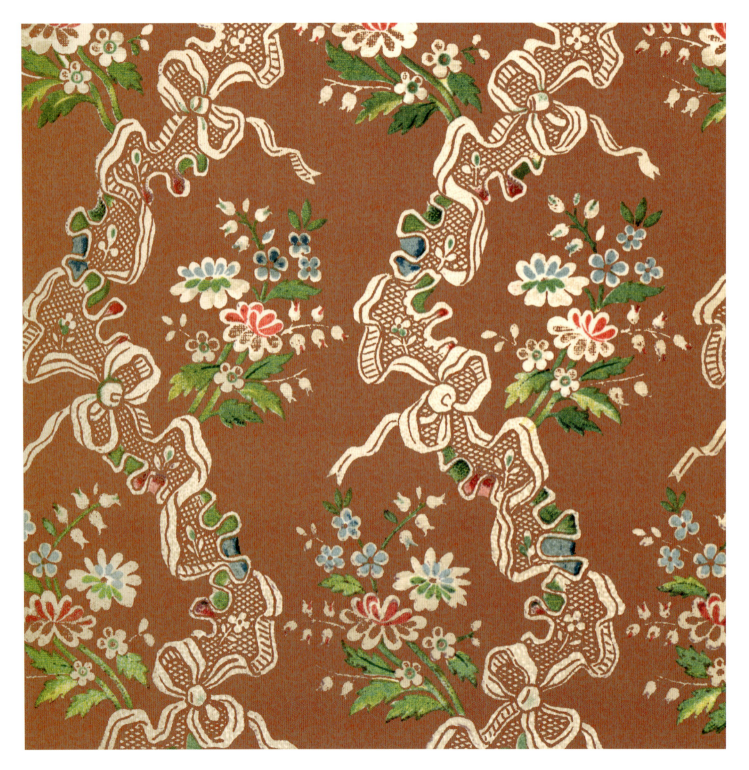

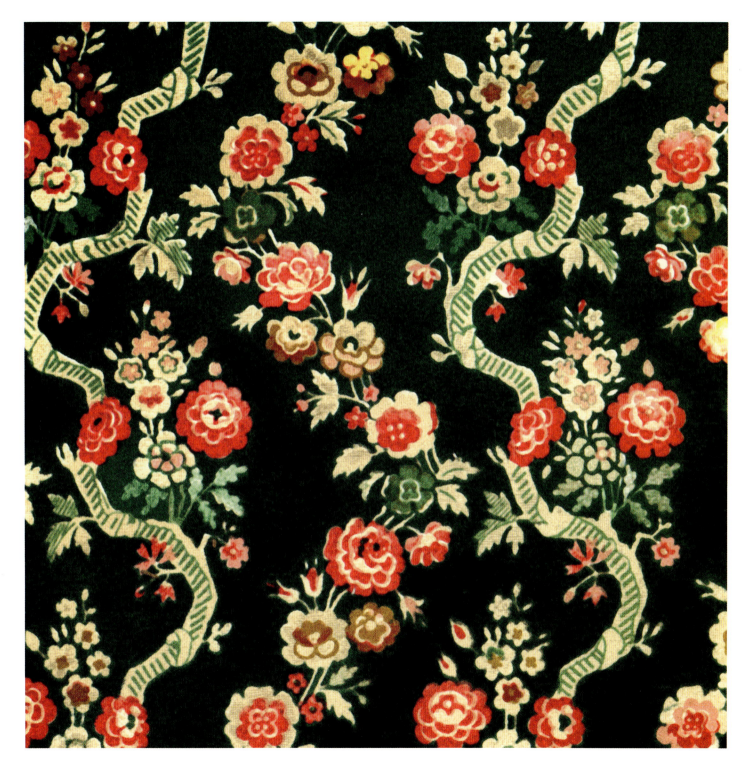

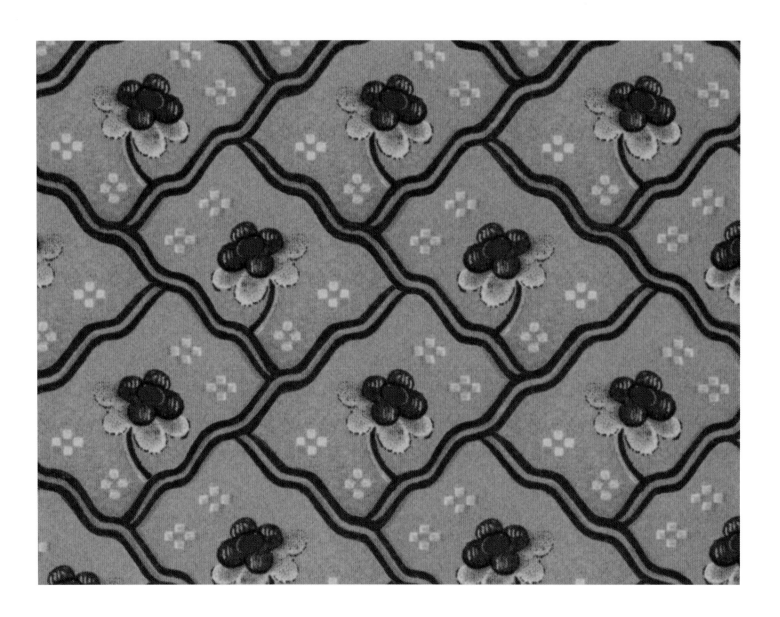

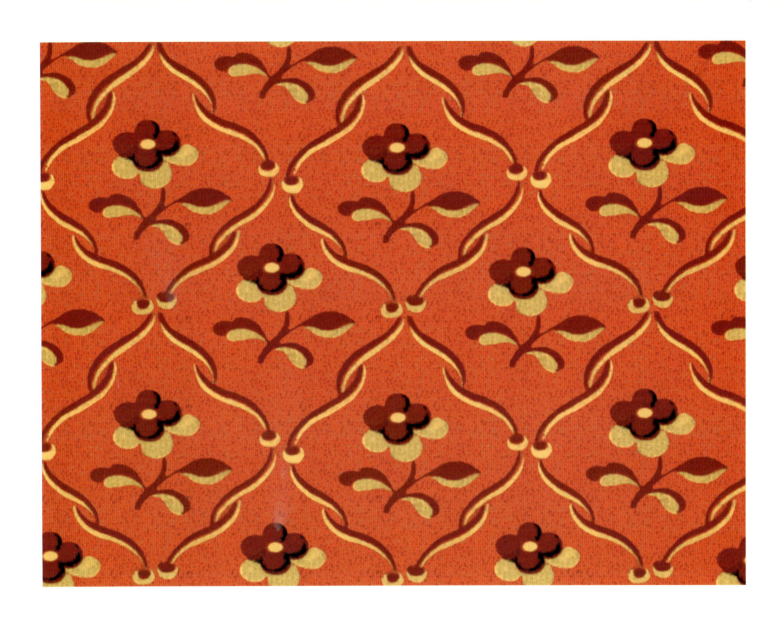

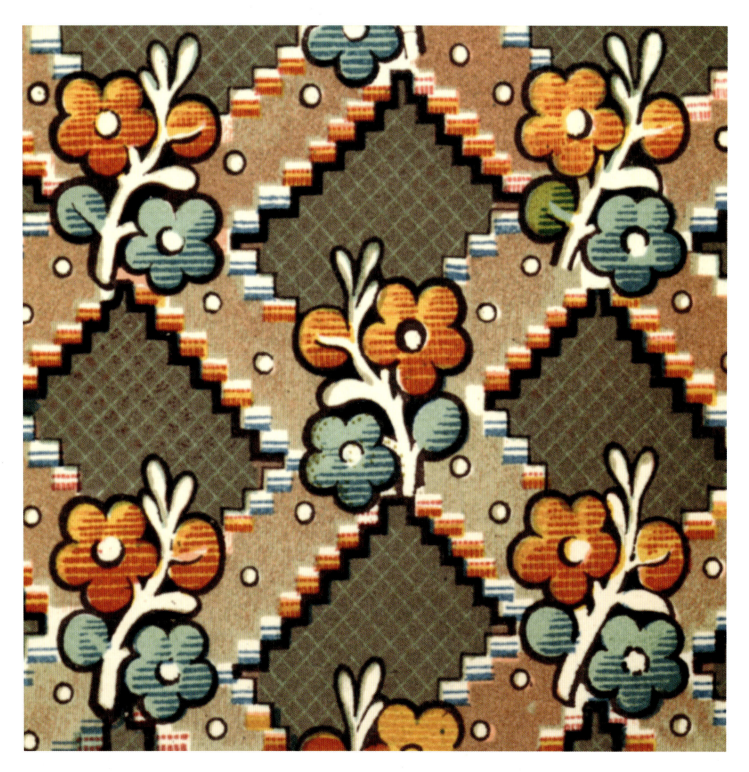